IMAGES
of America

FAIRMONT

D1598052

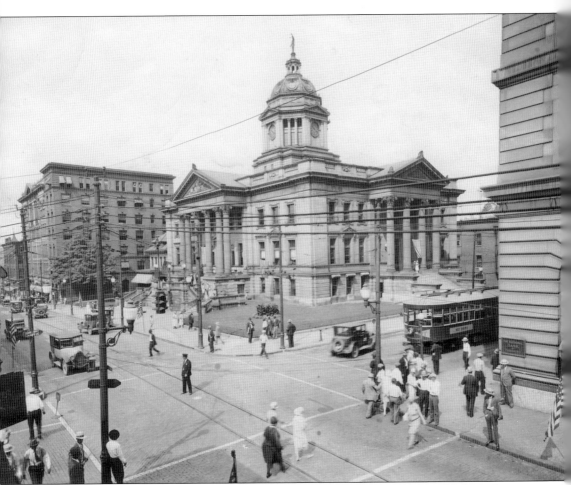

In this 1929 image, traffic officer Harry Curtis coordinates pedestrian, automobile, and streetcar traffic at the intersection of Adams and Jefferson Streets in front of the Marion County Courthouse. (Courtesy of the Marion County Historical Society & Museum.)

ON THE COVER: A close-up of the 1929 image shown above offers a better look at the courthouse square in downtown Fairmont. The streetcar in the photograph is the *West Virginia*; according to John Champ Neely, this streetcar was the queen of the entire system because it was a deluxe car specially fitted with 52 parlor seats. It made the trip between Fairmont and Clarksburg in 47 minutes. (Courtesy of the Marion County Historical Society & Museum.)

IMAGES
of America

FAIRMONT

Christa Lynn Greco

ARCADIA
PUBLISHING

Published by Arcadia Publishing
Charleston, South Carolina

Printed in the United States of America

Library of Congress Control Number: 2012948836

For all general information, please contact Arcadia Publishing:
Telephone 843-853-2070
Fax 843-853-0044
E-mail sales@arcadiapublishing.com
For customer service and orders:
Toll-Free 1-888-313-2665

Visit us on the Internet at www.arcadiapublishing.com

To my husband, Rick, for his support and mutual love of history; and to our daughters, Lexi Anna, Natalie Jo, and Adriana Louise—never forget where you come from so that you might see where you are going

CONTENTS

ACKNOWLEDGMENTS

This book is the culmination of the efforts of generations of people who had a love for posterity, family, history, and charity. Without their generosity or dedication to preserving their own family histories, this book would not have been possible. Everyone who contributed to this book did so voluntarily and without remuneration, including the author. In fact, all of the author's proceeds from the sale of this book will go to the Marion County Historical Society & Museum to further advance their mission of preserving the history of Fairmont and Marion County.

The staff and members of the Marion County Historical Society & Museum—including society president Dora Grubb, Gladys Miller, Patrick Watts, Gena Wagaman, Betty Andrews, JoAnn Lough, Dr. Frederick Fidura, Dr. James Matthews, Dr. George and Kathy Sprowls, Royal Watts, and George Ramsey—have been invaluable to this effort. A special nod is always owed to our late historians, Thomas Koon, Sylvester Myers, George Dunnington, and Glenn Lough, for the written legacies that continue to benefit all of us. Most of the images in this book are courtesy of the Marion County Historical Society & Museum (MCHS).

I would like to thank my editor, Lissie Cain at Arcadia Publishing, for her endless patience and expert guidance.

I also wish to express thanks to Dora Grubb and Jane Gilchrist for keeping the prodding iron firmly in place and encouraging and assisting me when I needed that little extra push; to Chuck Fink for your love of family history, your support of this endeavor, and for providing me and the readers of this book with a glimpse into your own family; to Wayne Kirby, who "accidentally" found himself contributing his historical expertise to this project; and to Louise Mundell and Patty Greco, who constantly fielded my onslaught of "do you remember" questions.

Finally, to all of the individuals, businesses, and organizations I contacted in person or via telephone, e-mail, or mail who answered my "call for images," thank you for your time and your contributions to this endeavor.

This book is not intended to be an all-encompassing dissertation on the history of Fairmont and its people, as that task has been tended to by others more worthy than I. For a more comprehensive review of Fairmont's history, please refer to the works listed in this book's bibliography.

INTRODUCTION

Oral and written history alleges that the City of Fairmont originated as part of property once owned by Jonathan Bozarth, the first "longtime" settler in Fairmont. In the early 1770s, Bozarth and his brother John settled on about 400 acres of adjacent land grants in Augusta County, Virginia, later transferring ownership to Thomas Barns then to the Flemings (John Fleming and his brother William Fleming's three sons, most likely Boaz, Benoni, and Nathan) when they arrived around 1789. In 1793, Jacob Polsley (or Paulsley) built a home on the east side of the Monongahela River in what was later called Polsley's Mills. His sons Daniel and John later sold the site to John S. Barns, who had it surveyed and, in 1838, established it as Palatine.

Between 1818 and 1819, Boaz Fleming employed William Haymond Jr. to develop and survey the property owned by Fleming and divide it into 85 city lots. In 1820, the Virginia Assembly (legislature) established this new town as Middletown, which became the county seat of Marion County in 1842, when it was formed from parts of Monongalia and Harrison Counties. In 1843, Middletown was incorporated as the Borough of Fairmont. In 1899, the West Virginia legislature granted the Borough of Fairmont a new charter by which the towns of Fairmont, Palatine (Polsley's Mills), and West Fairmont (formerly known as Johntown, Flemingsburg, and Pettyjohn) were incorporated as the City of Fairmont. In 1913, the town of Barnesville (formerly Buffalo Creek, Buffalo Station Barns' Settlement, Barns' Mill, Barnstown, and Damascus Mills) was also incorporated into the City of Fairmont.

Fairmont underwent a radical transformation as it ushered in the Second Industrial Revolution and evolved from an agrarian community to one that embraced industries such as coal mining, natural gas extraction, and glass manufacturing. These industries, as well as the transportation sector (especially the construction of the Baltimore & Ohio (B&O) Railroad), fueled an increasing demand for skilled and unskilled labor. This resulted in an influx of European workers and an increase in demand for local laborers in manufacturing plants. As a result, the city's population surged 728 percent from 1850 to 1900. In the 1900s, Fairmont became the most diversified and plentiful city in the region, and it was rumored to be home to more than 100 millionaires with ties to the coal industry.

Fairmonters proved to be a hardy bunch despite overwhelming obstacles, all of which coincidentally happened in the month of April—the flood of April 5, 1852; the Jones-Imboden Raid on April 29, 1863; and a fire that destroyed the business district on April 2, 1876.

The flood of 1852 is said to have destroyed thousands of dollars of property, particularly along the West Fork River, as numerous homes (some say 40 or more), gristmills, and businesses were swept away and floated down the river.

On April 29, 1863, at Fairmont, Confederate generals William E. "Grumble" Jones and John D. Imboden waged the largest battle ever fought in this part of the state. Their forces numbered more than 2,000, and these Confederates battled 500 regulars, home guards, and volunteers—civilians were involved on both sides, and the Confederate forces ultimately prevailed. They removed

books belonging to Francis H. Pierpont, governor of the Restored Government of Virginia, from an outbuilding that served as a library, then dumped them in the middle of Quincy Street and burned them. The Confederates also exploded an iron railroad bridge that crossed the Monongahela River.

The fire of April 2, 1876, started in the Prendergast saloon and soon spread to engulf more than 20 businesses and residences along Adams Street; it left more than 11 families homeless.

The visionary leaders and the wealth that they poured into the city allowed it to grow and prosper. These leaders provided jobs for numerous local, regional, and international laborers. They invested their time and money into projects that would make living in Fairmont a little bit easier. Additionally, other businesses contributed to the town's revenue—cabinet shops, a foundry, a planing mill, and saw and flouring mills that operated on steam and water. Soon, Fairmont would have electricity, mass transportation, and neighborhoods developed farther to the south. Although the city was not lacking for anything, some donated money and time to improve Fairmont. For example, during Thomas Fleming's mayoral administration, he loaned the city the money to establish the first water distribution system and also directed the first street-paving project.

Opportunities for education, healthcare, and other services were plentiful. Schools and hospitals witnessed considerable growth, as did hotels, since they catered to transient workers and visiting dignitaries. Numerous congregations of various faiths built houses of worship in Fairmont in the late 1800 and early 1900s, including Presbyterian, Methodist, Baptist, Episcopal, and Roman Catholic.

In addition to the notable Pierpont, who was instrumental in the formation of the state of West Virginia and who was the governor of the Reorganized Government of Virginia from 1861 to 1865, four other West Virginia governors hailed from Fairmont: Aretas Brooks Fleming, the eighth governor (1890 to 1893); Ephraim Franklin Morgan, the 16th governor (1921 to 1925); Matthew Mansfield Neely, the 21st governor (1941 to 1945); and Joseph Anthony Manchin III, the 34th governor (2005 to 2010). Fairmont was also home to James O. Watson and his son, US senator Clarence W. Watson, and son-in-law, former governor Aretas Brooks Fleming; these men controlled Consolidation Coal Company (now CONSOL Energy) for many years.

The photographs included in this book document significant moments in Fairmont's history, providing future historians with a brief understanding of the forefathers of the city, a context surrounding the environment in which they and their families lived and worked, and the impact their foresight and decisions had on future generations.

One

SETTLING THE LAND

Historians have established that the Hurons were the first people to arrive in what is now West Virginia in the late 1500s to early 1600s, followed by the Mound Builders, the Iroquois Confederacy (Mohawk, Onondaga, Cayuga, Oneida, and Seneca tribes) and the Shawnee, Mingo, and Delaware. The first permanent English settlers in present-day Marion County arrived in the Fairmont area during the 1760s. Some accounts suggest that John Beall, who came to the area in 1763, was the first to arrive. Others credit Jacob Prickett, who arrived in 1766, as the first settler. Capt. James Booth and John Thomas arrived in 1770 or 1772, as did Thomas Helen.

Once word spread that land was up for grabs (a result of Virginia governor Robert Dinwiddie's campaign for volunteers for land), hundreds flocked to the Fairmont area from Eastern Virginia, Maryland, and Delaware via a route called Braddock's trail. Pioneers sustained themselves by raising livestock and growing crops—since nearly every household had a hand mill, they milled their own grains for flour; most households also had looms and spinning wheels, so they weaved and sewed their own garments; and they tanned their own leather. The pioneers ate beef, pork, venison, turkey, bear, potatoes, cabbage, corn, etc. Pioneer David Morgan reportedly produced and sold salt from a well on his property located at what is now Edgemont; Saltwell Street was named in remembrance of his contribution.

In 1820, Fairmont was established on Boaz Fleming's farm. Documented accounts from court records and correspondence suggest that Fleming and others wanted to have a county seat centrally located between Morgantown and Clarksburg for ease of settling business and paying taxes. Fleming took the initiative to begin this process by separating his 254-acre farm into 85 half-acre lots for a new town. He sold the lots at prices ranging from $10 to $100 or more.

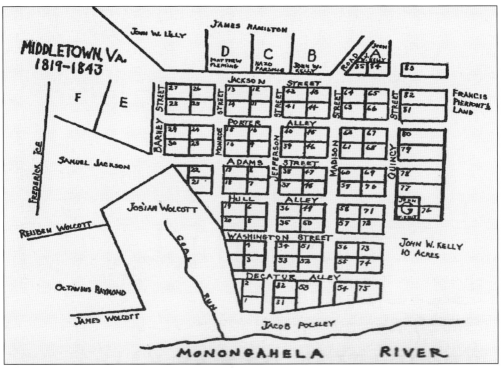

Between 1818 and 1819, Boaz Fleming employed William Haymond Jr., son of Maj. William Haymond, to survey the land that would eventually become Fairmont. This is the earliest map available depicting the layout of 85 lots and the names of various property owners. (MCHS.)

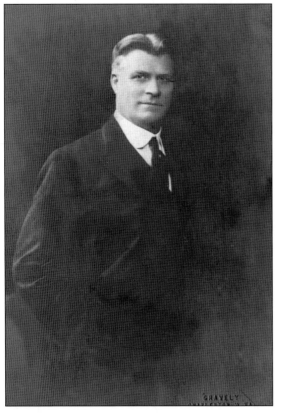

In March 1776, Zackwell and David Morgan—pioneers, Revolutionary War heroes, and brothers—surveyed the site of the town of Pleasantville, which is now Rivesville. Ephraim F. Morgan, a direct descendant of David Morgan and David's father, Morgan Morgan (the first white settler in Western Virginia), served as the 16th governor of West Virginia, holding office from 1921 to 1925; he is pictured here around 1900. (MCHS.)

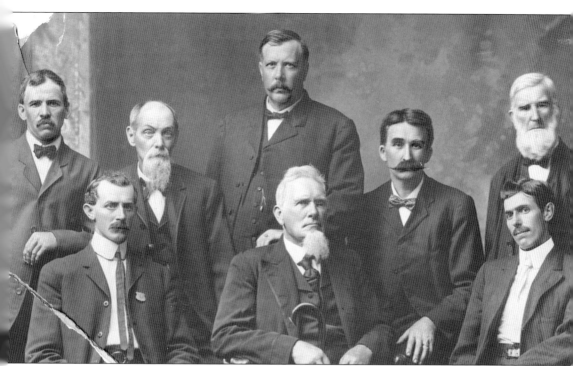

Barnesville was incorporated into Fairmont in 1913 as the fifth ward. Barnesville was settled as Buffalo Station and later called Barn's Settlement, Barns' Mill, Barnstown, Damascus Mills, Barnesville Incorporated, and Bellview. Thomas Barns' Buffalo Creek Mill was the first mill in the Fairmont area. In 1822, Barnesville was home to the one of the first post offices in the Fairmont area, although some believe that the area's first post office was in Polsley's Mills. This 1907 photograph shows the first municipal officers of Barnesville. They are, from left to right, (first row) Lee Fenton, William Meredith, and Willis Wilson; (second row) N. "Lum" Merrifield, John Phillips, Levi "Dumbo" Harn, George Toothman, and Billy Miller. (MCHS.)

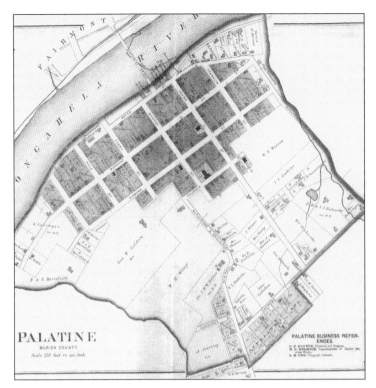

PALATINE

MARION COUNTY

Scale 250 feet to an Inch

PALATINE BUSINESS REFER-
ENCES.

Jacob Polsley settled in the area across the river from Middletown—on the "east side"—between 1790 and 1793 on 138.5 acres he purchased from Amy Prickett and Hannah Bunner. This area was called Polsley's Mills. The town of Palatine was formally established from Polsley's land and an additional 58.5 acres following a 1838 survey made by William H. Haymond Jr. and John S. Barns, and it was incorporated in 1867. By 1899, Palatine was incorporated into the city of Fairmont. This is a c. 1886 map of the Palatine area. (MCHS.)

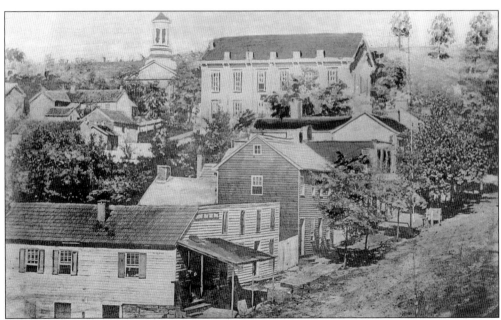

This retouched 1885 photograph looks up Adams Street toward Quincy Street in early Fairmont. Edd McCray's store and residence is in the foreground, followed by the Eyster residence and the Chisler home, which built in 1850 as a hardware store. The Methodist Protestant church is visible in the left-center background, and the two-story building in the center background is the West Virginia Normal School at Fairmont. (MCHS.)

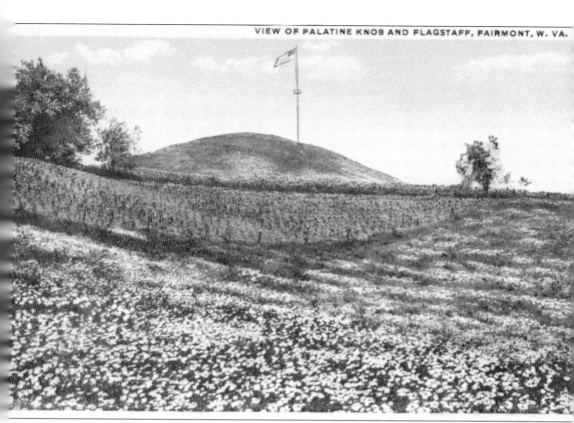

This postcard shows Palatine Knob prior to the development of the area. Palatine, which became the first ward of Fairmont in 1899, boasted several thriving businesses on Merchant and Water Streets, including the Palatine co-op, Levell's millinery, Nelson's bakery, Leonard's furniture store, Stealey's confectionery, Lloyd and Son's general store, Levell's grocery, Ohley's book-bindery, the Marion Foundry and Machine Company, Queensware Pottery Company, Samples Drug Store, Koen's Marble Shop, Scott's general store, and the Barns mill. Longtime resident Joe Weeks remembers when Palatine Knob was used as a mail drop—a mailbag was affixed on a rope strung between two poles, and a plane with a hook would fly low enough to snag the bag; sometimes it would just knock the bag off, making it roll downhill. As young boys, Weeks and his friends would run down the hill after the lost mailbag, then take it back up and reattach it to the rope. (MCHS.)

The Flemings were one of Fairmont's founding families and a prominent fixture during the town's formation, expansion, and establishment of a government. This is the Aretas Brooks Fleming property at 207 Jefferson Street. It was previously owned by Samuel Jackson, who had purchased it from Boaz Fleming on August 6, 1819. This building has housed the American Legion and CJ Maggie's Restaurant. (MCHS.)

The Post purchased the Governor A. B. Fleming property from Brooks Fleming, Jr., sole surviving heir, and was finalized on September 27, 1943. PURCHASE PRICE WAS $34,000, which included garage and seven room apartment.

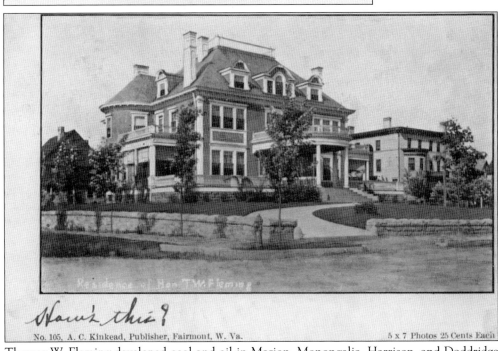

Thomas W. Fleming developed coal and oil in Marion, Monongalia, Harrison, and Doddridge Counties and also served two terms as mayor of Fairmont. This is his residence, which was built at 300 First Street in 1901. In 1938, the Woman's Club of Fairmont purchased it from Allison Sweeney Fleming and other heirs, and the mansion still serves as their clubhouse. (MCHS.)

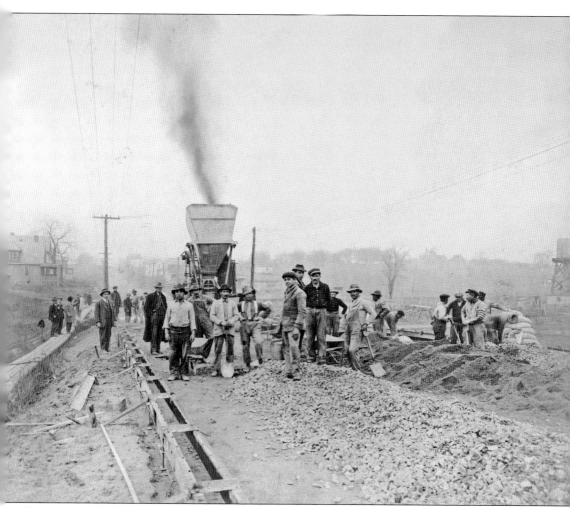

European immigrants seeking employment came from Hungary, Poland, Germany, Austria, Italy, Turkey, Greece, Belgium, France, and Ireland to work for the coal mines, railroads, gas companies, glass factories, and various mills in and around Fairmont. Immigrant workers were also instrumental in laying the many miles of road in and around Fairmont. Here, workers pose for a photograph in front of a steam-driven mixer as they prepare to pour curbs and lay the sand, stone, and gravel for what appears to be Fairmont Avenue. Since the first road was "paved" during Thomas Fleming's mayoral administration in 1892, this photograph was likely taken in the early 1900s. (MCHS.)

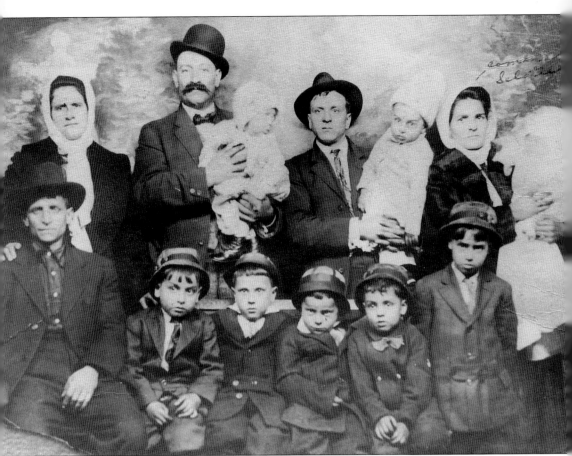

Francesco Bitonti Sr. was born in 1885 in the village of San Giovanni in Fiore in the Calabria region of Italy. He was the son of Guiseppe and Anna Maria Urso Bitonti and served 12 months in the Italian army until June 16, 1905. Tommasina Nicoletti, born in 1887 in the village of San Giovanni in Fiore, was the daughter of Francesco Nicoletti and Laveria Biafore. Francesco and Tommasina married in 1903 and came to America. They resided at 1301 Chamberlain Avenue, where the family fondly remembers watching football games from their aunt Annie Bitonti's bedroom window, which overlooked East-West Stadium, and spying on adults from a vent in the second-floor hallway. The Bitonti family is pictured here in the early 1900s, with Tommasina and Francesco Bitonti Sr. in the second row (first and third from the left, respectively) and Joe Bitonti and Francesco "Buckeye" Bitonti Jr. in the first row (third and fourth from the left, respectively). (Bitonti family.)

Two

INDUSTRY

Farming and timber were the leading industries in the Fairmont area starting around 1791. The 1800s ushered in the Industrial Revolution and significant advancement in industries including coal, oil, and natural gas extraction; glass manufacturing; electricity distribution; and transportation.

The first coal mines were created for domestic purposes—farmers dug into the hillsides of their properties using picks and shovels and transported the coal by sled for use in their homes. In 1850, a man named Jimmy Burns opened a coal mine near Gaston Avenue and Second Street, selling the mined product to others. The first commercial mine appears to have been the O'Donnell mine, which opened in 1852 on Palatine Knob. The first load from this mine was shipped to Baltimore via railroad in 1853.

According to the November 2, 1892, edition of the *Fairmont Free Press*, The Fairmont Manufactured and Natural Gas Company brought natural gas "to town" on October 31, 1892, and provided citizens who were fortunate enough to already have their houses "piped" with the gas they needed for heating and cooking. In the article, general manager Mr. Gregory was quoted as saying, "plumbers had plenty of work at that time and were behind on their orders to the point that it would take them weeks to catch up."

Based on the availability of glass sand and abundant natural gas, Fairmont developed a major glass industry in the early 1900s. Experienced glass workers were brought in to operate the plants and train new workers. Many came directly from Belgium, France, and Italy, while others who had immigrated to work at Pennsylvania or Ohio glass plants were persuaded to transfer to Fairmont.

The transportation sector also witnessed a surge in development with the streetcar system, the B&O Railroad (the Fairmont line was completed in January 1852), river navigation, and road and bridge construction. Fairmont emerged as a hub of industrialization and economic development, fueling an increasing demand for skilled and unskilled labor that resulted in an influx of Austrian, Belgian, French, German, Greek, Hungarian, Italian, Polish, and Turkish people who immigrated to Fairmont to support the burgeoning industries.

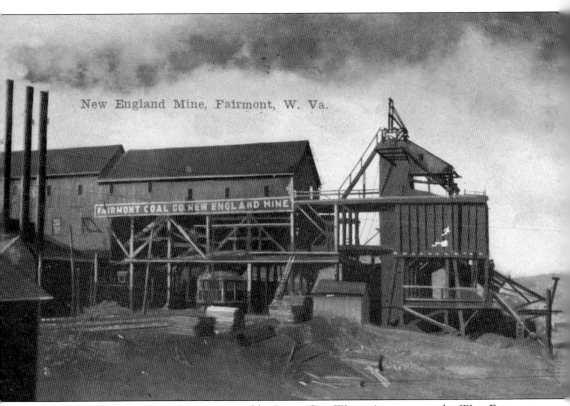

New England Mine, Fairmont, W. Va.

FAIRMONT COAL CO NEW ENGLAND MINE

This c. 1900 image shows a mine owned by James Otis Watson's company, the West Fairmont Coal & Coke Company. Watson bought this mine from the New England, Fairmont & Western Gas Coal Company in 1894. The mine's previous owners had built a bridge (which was replaced by the Hunsaker Covered Bridge, which in turn was later replaced by the Watson Bridge) across the West Fork River before working this mine for a short time and then abandoning it to deteriorate. After Watson's company bought the mine, it rebuilt the railroad, erected a town named New England (later renamed Watson), and made improvements to the mining operation such as replacing child labor with automatic coal screening equipment and installing new dumps and car hoists in the tipple. Watson's modern New England Mine eventually became the largest coal producer in Marion County. (MCHS.)

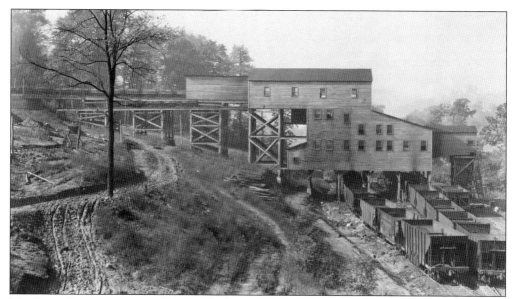

The Laura Lee mine, pictured here in the late 1800s, was owned by Clyde Effington Hutchinson, who also owned the Hutchinson Coal Company. Hutchinson also had other business interests with his brother Melville, including Hutchinson Fuel and Supply, located in the Jacobs Building, and the Hutchinson-Barnes Brick Company at 639 Fairmont Avenue. (MCHS.)

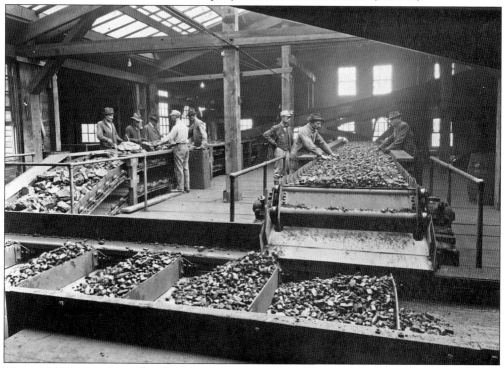

This c. 1900 image shows "breakers"—coal sorters—using bare or gloved hands to sort and break up coal. Before modern techniques evolved to a point at which machines could identify impurities, "breakers" had to sort the coal and break it into small pieces before it was sent to be screened by hand, with the use of animals, or with steam power or waterpower. (MCHS.)

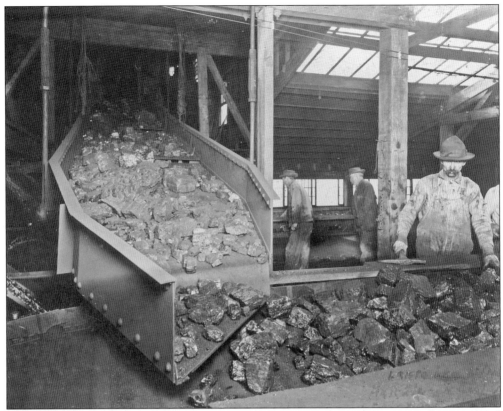

This is another photograph of the sorting area, where coal came down the chute to be sorted and broken up by hand. The employee in the foreground is holding either a pick or a sledgehammer to break up the coal. Sorting was done by either men or boys. In later years, all of these processes became automated. (MCHS.)

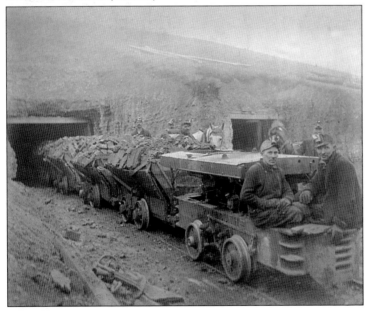

A coal car known as a wagon was used to haul raw coal from the mines to the coal breaker. Each car held approximately 500 tons of coal. Note the two horses behind the cars in the background. It is possible that the Marion Foundry and Machine Company provided the wooden coal cars pictured here. (MCHS.)

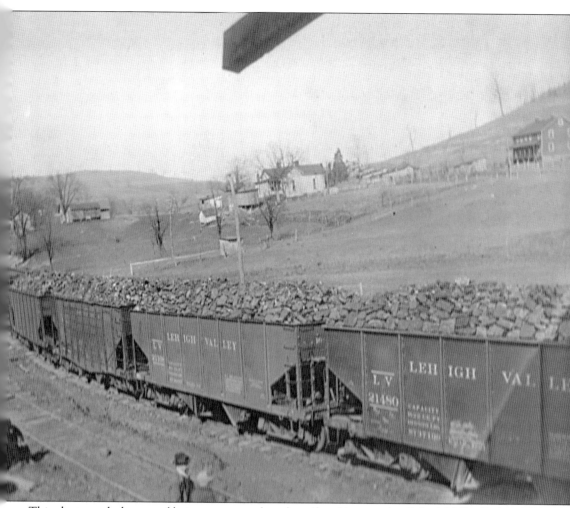

This photograph shows coal being transported on the railroad in a two-bay Lehigh Valley Railroad hopper car. Railroads were instrumental in the commercial sale and distribution of coal. The development of the Fairmont field began after the completion of the B&O Railroad in 1852 and continued into the 1900s. Principal growth and development occurred in the vicinity of Fairmont and Clarksburg along the route of the railroad. The tracks were built using granite stringers topped by strap-iron rails and were completed in Fairmont in June 1852. The Fairmont, Morgantown & Pittsburgh branch of the B&O, which traveled from Fairmont to Morgantown, was completed on February 1, 1886. On April 1, 1894, it was extended to Uniontown, Pennsylvania. By the 1910s, the Fairmont, Morgantown & Pittsburgh branch had very heavy freight traffic, especially of coal. The distance between the between the Fairmont and Point Marion, Pennsylvania, railroad stations was 38 miles. (MCHS.)

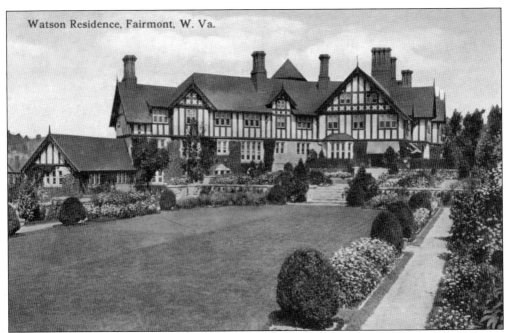

Watson Residence, Fairmont, W. Va.

James Edwin, Clarence, and Sylvanus Watson, along with Aretas Brooks Fleming, made up the most powerful business and political group in the region in the 1900s. This is James Edwin Watson's estate (aka High Gate), built in 1912 at 801 Fairmont Avenue. The main house, which is in the National Register of Historic Places, is now the Ross Funeral Home. (MCHS.)

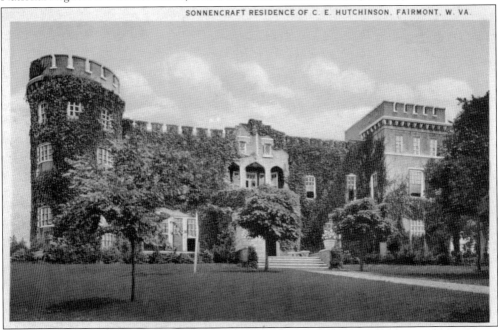

SONNENCRAFT RESIDENCE OF C. E. HUTCHINSON, FAIRMONT, W. VA.

This postcard shows Clyde E. Hutchinson's residence, Sonnencroft, which was completed in 1912 on Morgantown Avenue. It is a stucco-and-tile replica of the Inverness Castle in Inverness, Scotland. It fell into disrepair and was sold to the Marion County Board of Education in the 1960s. The grounds will soon be home to the new East Fairmont Middle School. (MCHS.)

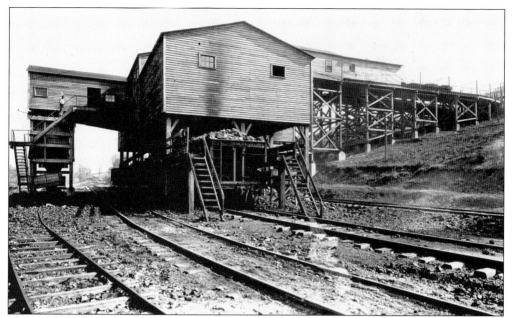

Many local coal operators allied with the interests of the Watson and Fleming families, selling their coal companies to them and starting new mines in other locations. Clyde Effington Hutchinson sold his interest in the Fairmont field around 1910 and then opened other coal mines in northern and southern West Virginia. This is a photograph of the Laura Lee mine in Fairmont, which was owned by the Hutchinson Coal Company. (MCHS.)

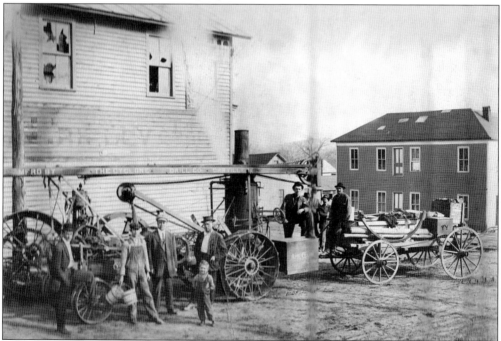

Portable, wheel-mounted Cyclone rigs were made by the Cyclone Drill Company based in Orrville, Ohio. Mining concerns used these rigs for test borings. This undated image shows a group of people surrounding a Cyclone rig in Fairmont. (MCHS.)

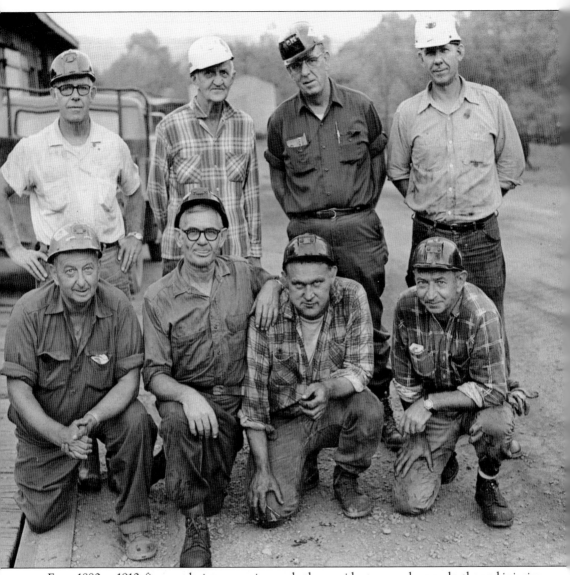

From 1880 to 1910, fires, explosions, cave-ins, and other accidents caused many deaths and injuries. Safety in the mines was a great concern. Between 1890 and 1912, West Virginia had a higher mine death rate than any other state. Canaries were once regularly used in coal mining as an way to warn against toxic gases such as carbon monoxide and methane—since the birds were smaller and thus more sensitive to environmental disturbances, when the canary died, the miners knew that it was time for them to get out of the mine. Workers used dogs, goats, mules, and horses to haul loads of coal out of drift mines and were often better cared for than the miners themselves. In the early days, miners often had to work while lying on their sides. As coal mining techniques evolved, so did mining safety, including regulations that require hard hats, lights, ventilation systems, and the like. In this mid-20th-century photograph, several workers pose at the Martinka mine. Joseph Weeks is on the far right in the second row. (Joe Weeks.)

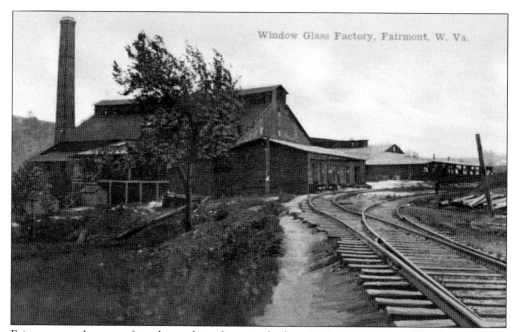

Fairmont was home to five glassmaking firms in the late 1800s. By 2000, it had at least 29. This postcard shows the Fairmont Window Glass Company factory, which was open from about 1905 to about 1924. It was located in Fairmont's south side, along the B&O Railroad below Minor Avenue between Tenth and Eleventh Streets near Johntown. (MCHS.)

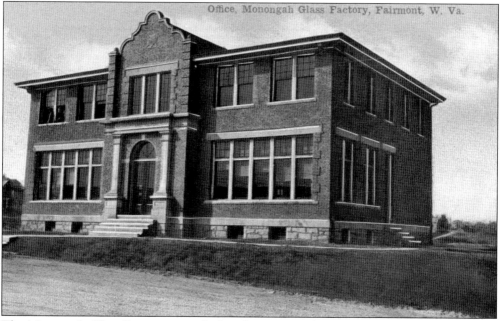

The Monongah Glass Factory, named after the Monongahela River, was on Twelfth Street. Established in 1903, it produced pressed and blown glassware. It was one of the first companies to use machinery to mass-produce glassware, and it made such huge quantities of glass that it was one of the largest glass factories in the United States by 1928. This postcard shows the company's office. (MCHS.)

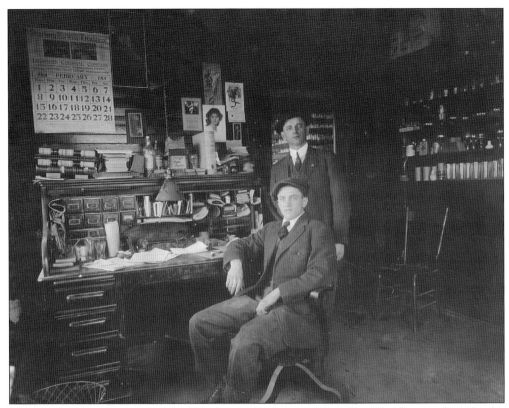

Two management executives from Monongah Glass pose in the office; the date on the calendar behind them is February 1914. James Edwin Watson, the industrialist and coal baron, held a controlling interest in several local businesses, including the Fairmont Coal Company, the Bank of Fairmont, a theater, the Watson Hotel, an opera house, the Fairmont and Clarksburg Traction Company, and the Monongah Glass Company, which closed in 1931. (MCHS.)

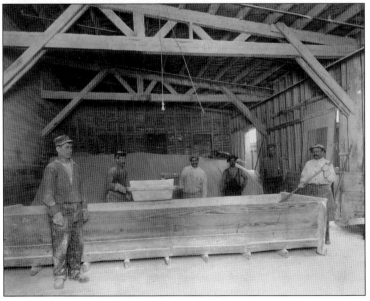

In this 1914 image, six unidentified "mixers" work in the Monongah Glass mixing room. They are possibly mixing silica sand, sodium oxide, calcium oxide, and lead in the trough and preparing the blend for the next stage of glassmaking. Note the large pile behind the workers—it appears to be silica sand. (MCHS.)

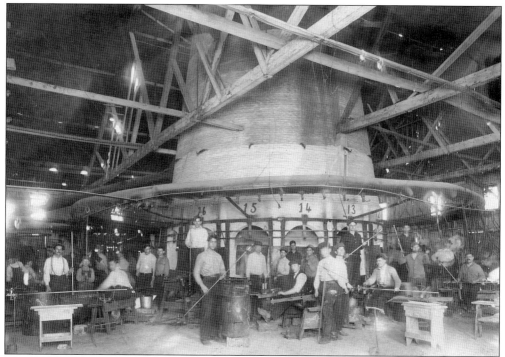

These Monongah Glass employees are working in the oven room, where the "glory hole" was located. The gaffers, or master glassblowers, hold blowpipes while the servitors, or mold boys, stand behind them. The servitor's tasks included assisting the gaffer and opening and closing the glass molds. (MCHS.)

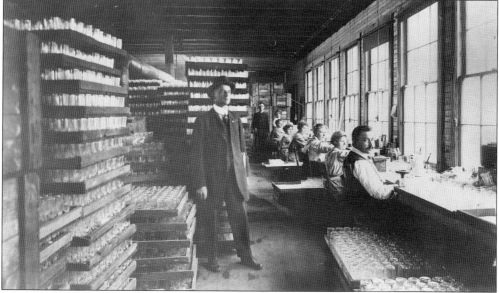

This 1914 photograph shows a supervisor and Monongah Glass decorating-room workers as they prepare to stencil or paint intricate designs and ribbons onto the glassware. Notice the thousands of glasses waiting to be decorated. Judging by the appearance of this crew, women must have been very adept at decorating glass, because they outnumber male workers. (MCHS.)

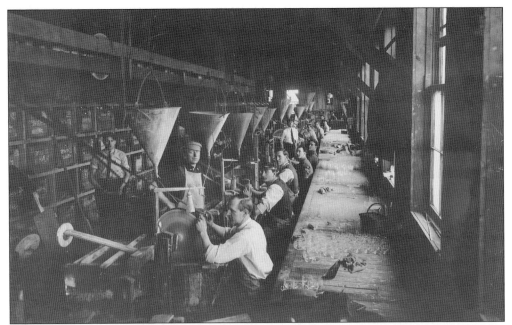

This 1914 photograph appears to show the polishing and grinding room at Monongah Glass. Note the worker in the foreground holding a glass to the polishing/grinding wheel. (MCHS.)

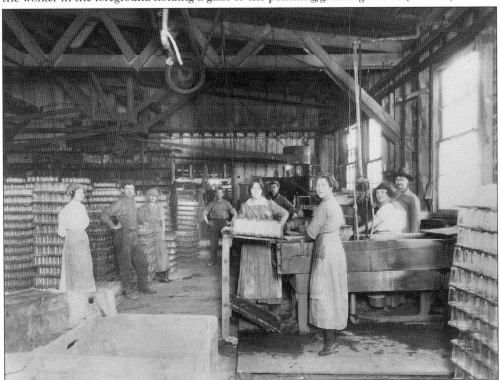

In this 1914 image, Monongah Glass washroom workers clean glassware to prepare it for packing and shipping. Note the thousands of glasses to be prepared and the inclusion of both men and women in the washroom area. (MCHS.)

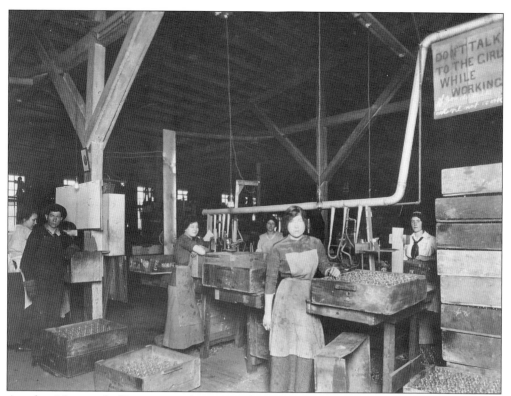

Another Monongah Glass picture from 1914 shows workers apparently doing some preparation work with the glassware. Note the sign in the upper right corner that says: "Don't talk to the girls while working. If you do talk, she will not work." (MCHS.)

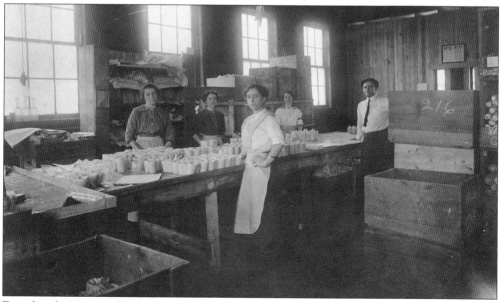

Four female Monongah Glass workers outfitted in dresses and aprons wrap glassware in paper (a common practice to prepare glass for shipping) while their male supervisor looks on in 1914. Several of the wooden crates are already filled with paper-wrapped glasses. (MCHS.)

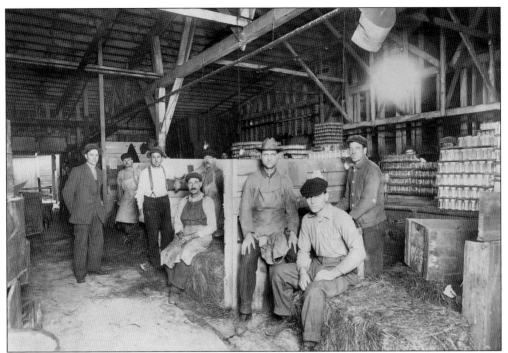

A group of warehouse, or storehouse, workers takes a break in this 1914 image. They sit on hay bales; at the time, hay was used in shipping, as were wooden barrels and/or crates. (MCHS.)

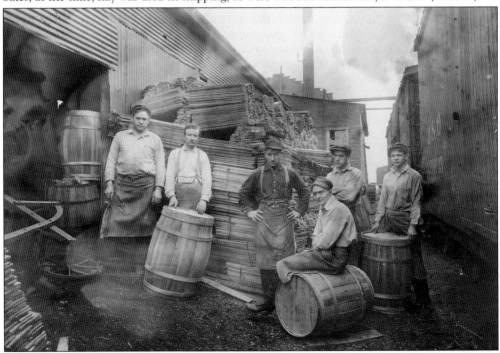

This group of Monongah Glass workers made these wooden barrels, which were to be stuffed with hay and glassware. This was a common shipping practice for both pottery and glass. This building was conveniently located next to the B&O Railroad tracks. (MCHS.)

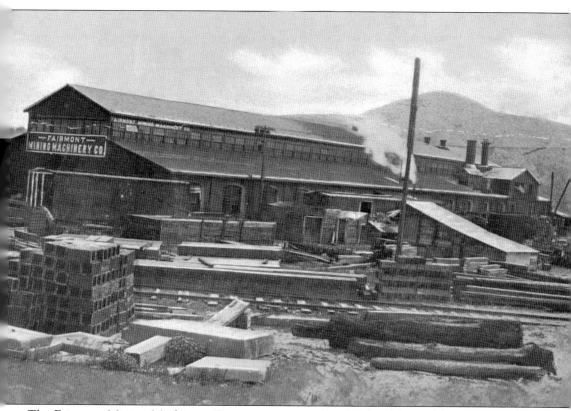

The Fairmont Mining Machinery Company, organized in 1905 and located between Ninth and Tenth Streets along the B&O Railroad, was capitalized with $500,000 and employed 250 people in 1915. According to a 1906 map of the Fairmont Development Company's addition to Fairmont, other nearby businesses included the Fairmont Wall Plaster Company, the Fairmont Window Glass Company, the Helmick Corporation, the Mountain City Stove and Foundry, and the Fairmont Bottle Works. Fairmont Mining Machinery Company furnished the steel for the construction of many of the coal-mining operations, as well as for the Fleming Building located at 109–113 Adams Street. According to a report by Henry W. Francis that quoted M.L. Brown, chairman of the Marion County Board of Commerce, as of November 25, 1934, the Fairmont Mining Machinery Company employed 250 to 300 men and was producing mining equipment, runways, tipples, and the like; was spasmodic in its operations; and was in receivership, only operating four days a week with layoffs imminent. This the company's factory, which was located at the foot of Tenth Street. (MCHS.)

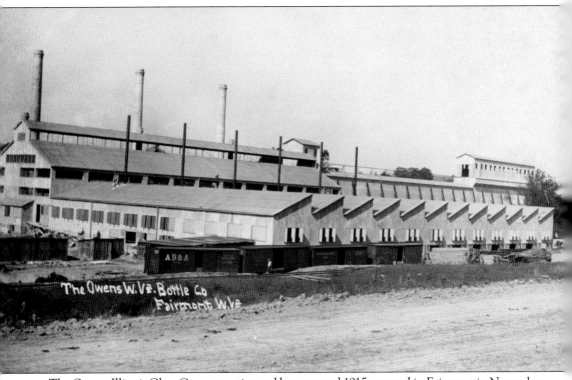

The Owens-Illinois Glass Company, pictured here around 1915, opened in Fairmont in November 1910 as the Owens Bottle Works. The factory was built on the east side of Fairmont between Speedway and Morgantown Avenues. Owens, as it was called, operated with three work shifts—day, afternoon, and midnight—well into the 1970s and employed as many as 1,000 people at one time. The plant ran all day and all night and produced up to 180,000 bottles per day. Owens-Illinois supported of a variety of sporting teams, sponsoring men's baseball and basketball teams and a women's softball team. As the local economy faltered and the demand for manufacturing in the Fairmont area slowed, Owens-Illinois closed its doors in March 1982, and the building was torn down. The property is now a vacant lot. (MCHS.)

STATEMENT OF EARNINGS AND DEDUCTIONS

G-30 G-10

1048 234-09-5656 HELEN TALKINGTON

EMPLOYEES NAME AND CLOCK NO.	REGULAR PAYROLL	BONUS PAYROLL
REGULAR EARNINGS—PERIOD ENDING FEB. 28, 1939	26 00	4 46
PREMIUM TIME — PERIOD ENDING FEB. 26, 1939		
TOTAL PAY		
FEDERAL OLD AGE PENSION	26	05
STATE UNEMPLOYMENT INSURANCE		
EMPLOYEES GROUP INSURANCE		
RESTAURANT COUPONS	1 00	
TOTAL DEDUCTIONS	1 26	
NET AMOUNT OF CHECK	24 74	4 70

EMPLOYEE—
WE SUGGEST THAT YOU KEEP THIS SLIP. YOU MAY WANT IT LATER IF YOU APPLY FOR BENEFITS UNDER THE SOCIAL SECURITY LAW.

This 1939 Owens-Illinois pay stub for Helen Talkington was for a grand total of $29.44. No federal or state taxes were withheld (with the exception of the Federal Old Age Pension). (MCHS.)

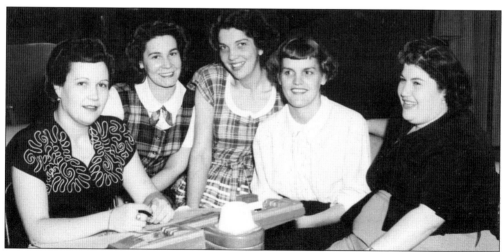

Owens-Illinois employees loved to socialize and have a good time, going swimming at Rock Lake, participating in company-sponsored sporting events, and hanging out at the local bowling alley. Here, women from the C shift gather for a game of bowling. From left to right, they are Louise Bunner, Elizabeth Lehosit, Vera Watkins, Gretchen Huffman, and Nellie Cirocco. (MCHS.)

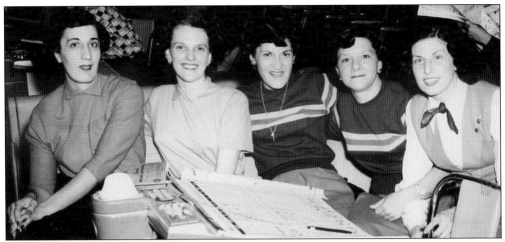

These are the Owens-Illinois D shift "Durabelles." They are, from left to right, Virginia Skagnelli, Billie Audia, Rose Celi, Margaret Christian, and Rosie Jane Oliverio. Owens-Illinois employed a large number of men and women in the Fairmont area. In many families, both spouses worked at the plant, and a lot of employees met their future spouses there. (MCHS.)

This building, originally the residence of Ulyssis N. Arnett, is pictured 70 years after it was first constructed around 1900. The two-and-a-half-story building was on the corner of Barney Street (now Cleveland Avenue) and Adams Street and was owned at various times by the trustees of the First Methodist Episcopal Church, the Fairmont Development Corporation, and Oliver Jackson's heirs. (MCHS.)

Three

COMMERCE

As Fairmont's population increased, the city's residents needed homes to live in and a monetary system to buy and sell goods and services with ease, and the city needed businesses that could support travelers with places to stay and eat. The first mill in Fairmont was Jackson's mill, which was founded in the early 1800s on a site later occupied by the Wise Packing Company. The mill ground grain and manufactured lumber used in the construction of homes and businesses in Middletown (Fairmont) and nearby villages.

In 1880, there were three banks in Fairmont: the First National Bank of Fairmont, organized in October 1853; the Mountain City Bank, opened on August 1, 1874; and the Farmers Bank of Fairmont, opened in 1875. According to *Myers' History of West Virginia*, written by Sylvester Myers, by 1914, the National Bank of Fairmont, First National Bank, Peoples National Bank, Home Savings Bank, Citizens Dollar Savings Bank, and Trust Company Bank were all in operation in Fairmont.

In the 1800s, in order to accommodate man and beast, all the downtown stores had mounting blocks in front for the convenience of customers who rode horses. Streets had stepping-stones at close intervals so people could cross the street without getting too muddy or wet. In 1852, after the completion of the B&O Railroad and the suspension bridge between Middletown and Palatine, passenger trains made frequent stops in Fairmont, which led to a new demand for places for the weary to rest and to the construction of the area's first hotels.

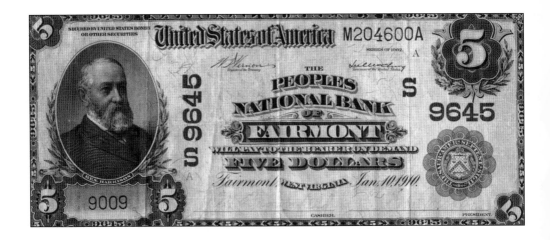

These images show the front and back of a $5 note issued between 1902 and 1908 by the Peoples National Bank of Fairmont. On the front is Pres. Benjamin Harrison and on the back is an artist's rendering of the landing of the pilgrims. The Peoples National Bank of Fairmont began in 1853 as the First National Bank of Fairmont and organized as a state stock bank at 123 Adams Street in 1854. In 1858, it changed to a free banking system, and it became chartered as a national bank in 1865. The bank relocated and changed names several times. (Both, MCHS.)

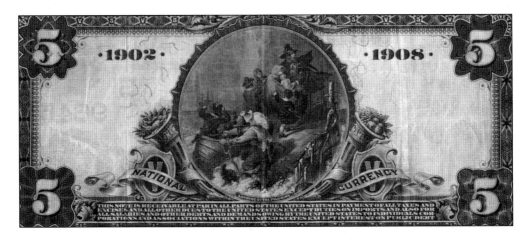

CERTIFICATE
No.
For 7 Shares
Issued to
Chas. Brett or Mrs.
E.A. Gilmour
Dated June 1st 1915
FROM WHOM TRANSFERRED

Dated 1|6|15 19
No. ORIGINAL No. ORIGINAL No. OF SHARES
CERTIFICATE SHARES TRANSFERRED
107 11 7
Received CERTIFICATE No.
For Shares
this day of 19

INCORPORATED UNDER THE LAWS OF THE STATE OF WEST VIRGINIA

FAIRMONT BUILDING AND LOAN ASSOCIATION
FAIRMONT, W. VA.
CAPITAL STOCK. $1,040,000.

This Certifies that Charles Brett Or Mrs. E.A. Gilmour
is the owner of Seven — Shares of the Capital Stock of
FAIRMONT BUILDING AND LOAN ASSOCIATION
transferable only on the books of this Corporation in person or by Attorney
upon surrender of this Certificate properly endorsed.
IN WITNESS WHEREOF, the said Corporation has caused this Certificate to be signed
by its duly authorized officers and its Corporate Seal to be hereunto affixed
this First day of June A.D. 1915

C.H. Jenkins
TREASURER

SHARES
$130 00
EACH

J.M. Hartley
PRESIDENT

This is a stock certificate for seven shares of Fairmont Building and Loan Association stock, issued in 1915 at a total cost of $910. The stock certificate was issued to Charles Brett or Mrs. E.A. Gilmour and appears to be authorized by Fairmont Building and Loan Association president J.M. Hartley and treasurer Charles Jenkins. The Fairmont Building and Loan Association evolved from the Fairmont Building and Investment Company, which began in 1903. It was located at 212 Cleveland Avenue and later at 309 Cleveland Avenue. In 1912, George Thomas Watson, who had previously served as the director of the Fairmont Trust Company, the general manager of the Fairmont and Clarksburg Traction Company, and the vice president of Consolidated Coal, was also the director of the Fairmont Chamber of Commerce and the Fairmont Building and Investment Company. Building and loan associations were vehicles for attaining independence and security, and many people favored these associations for financial assistance in constructing residential homes. Additionally, a large number of patrons also became stockholders. (MCHS.)

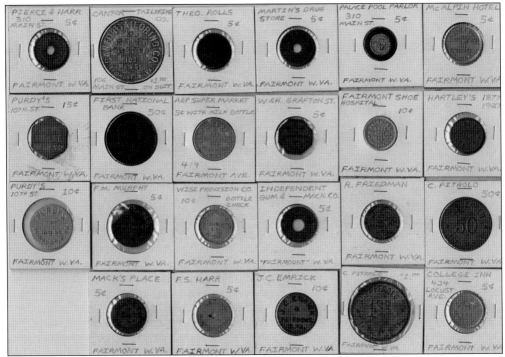

The practice of loyalty marketing, in which a merchant distributes tokens to be collected by consumers and exchanged for items or services, has been around at least since 1793 in the United States. The practice caught on rapidly and was used by many merchants throughout the 1800s. This image shows several tokens issued by Fairmont merchants. (MCHS.)

This photograph shows additional tokens sponsored by retail establishments in Fairmont and, in the upper right corner, what appears to be a luggage tag for the Watson Hotel. The sleeves the tokens were stored in noted their value and the establishment that issued them. (MCHS.)

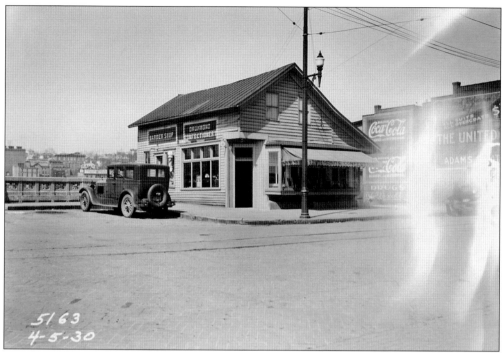

5/ 63
4-5-30

This picture from April 5, 1930, shows the barbershop and Drummond Confectionery. This building was on Merchant Street near the entrance to the bridge on the east side of the Monongahela River. (MCHS.)

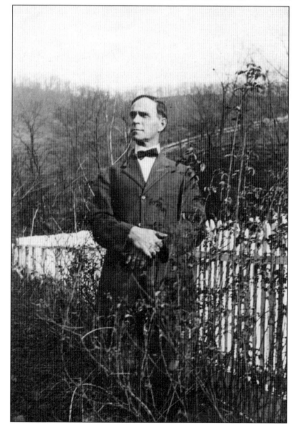

Charles Coleman Conaway (1855–1915) married Mary V. Sturm, and the couple had 12 children. He was a prominent businessman, pioneer, patriarch, and churchgoer. He also may have been affiliated with the Conaway Feed Store. (MCHS.)

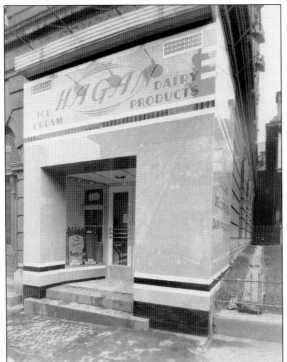

Hagan, located at 209 Adams Street, was a popular spot in downtown Fairmont to cool off with an ice-cream cone, milk shake, or soda pop. The building was erected between 1904 and 1905 for the Fairmont Trust Company and was the first building in the city with reinforced concrete floors. Locals may remember that in addition to the Fairmont Trust Company, the Home Savings Bank also used this building. (Robert Bice III.)

According to the menu behind the counter, when this photograph was taken, one quart of Hagan ice cream was 45¢. This building is situated to the left of the former sheriff's residence (which is now home to the Marion County Historical Society). (Robert Bice III.)

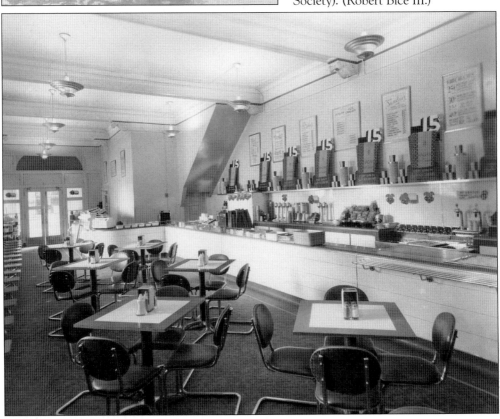

The venerable Palace Restaurant, operated by Spiro Gotses and located at 123 Adams Street, was a Fairmont staple from 1919 through the 1960s. Locals remember meeting there after a night on the town, as well as the restaurant's famous pecan rolls that were made upstairs in the bakeshop. (Linda Rutherford, in care of MCHS.)

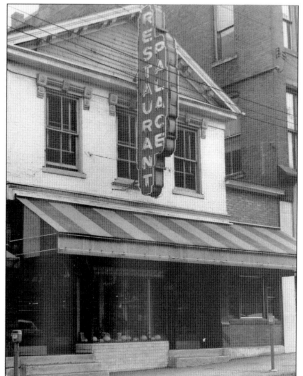

Several other businesses were housed at 123 Adams Street before the Palace Restaurant moved in, including the office of the Italian consul, J.W. Mariana, who then opened an Italian bank at the location in 1904. The location was also home to the Busy Bee Restaurant in 1909, the Hub clothing store in 1912, and the Anderson Restaurant in 1917. The image below offers a glimpse of the Palace Restaurant in the 1950s. (Linda Rutherford, in care of MCHS.)

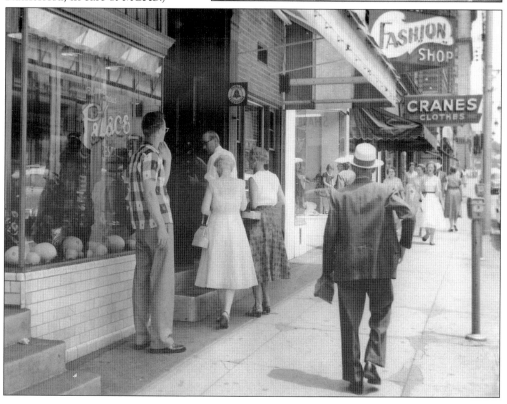

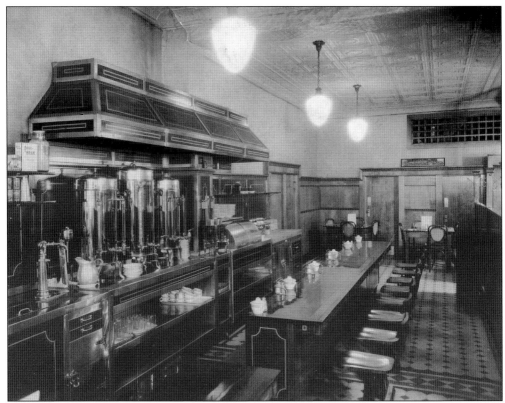

This interior view of the Palace Restaurant shows the black onyx finish on the countertop and the shiny equipment behind the counter. In the late 1930s, a hamburger cost 15¢, a chef salad was 35¢, and a T-bone steak was 90¢. (Linda Rutherford, in care of MCHS.)

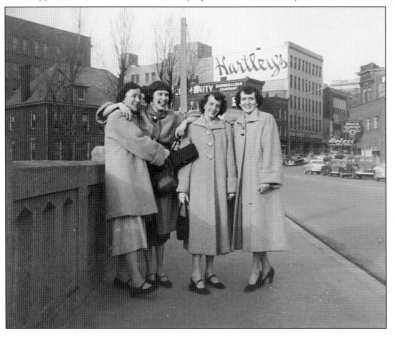

This 1940s photograph shows (from left to right) Jenny Yeager, Peggy Mason, Wilma Currey, and Edith Currey posing on the South Side Bridge, which spans the Mid-City/Ravine Park parking lot. Hartley's Department Store is in the background. (Kim Rhoades.)

H.A. Dodge Jewelers, the O.J. Morrison department store, Frances Dress Shoppe, and Hartley's Department Store were popular businesses in downtown Fairmont. The proprietor of Frances Dress Shoppe was supposedly a relative of Reuben and Marvin Fink, brothers who worked in men's retail. This image looks south on Adams Street. (MCHS.)

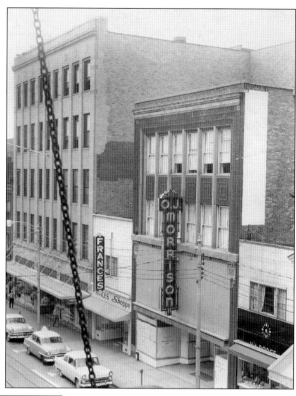

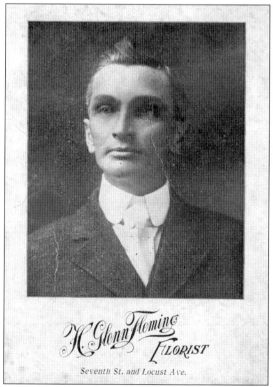

Horace Glenn Fleming, born in 1866, was a florist whose shop was at the present-day corner of Seventh Street and Locust Avenue. Based on a review of 1912 Sanborn maps of Fairmont, the western side of Seventh Street was named Floral Avenue at the time. Fleming's greenhouses were located just two blocks from Locust Avenue along Floral Avenue. (MCHS.)

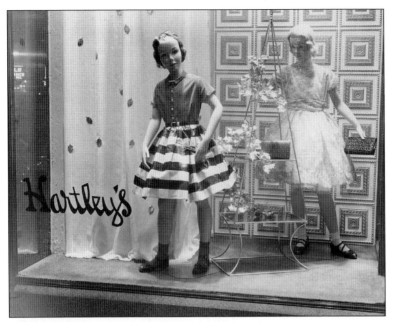

Many fondly remember Hartley's Department Store, especially their display windows, which were always impeccably designed at their 117 Adams Street location. This window display shows off fall fashions for young ladies. (MCHS.)

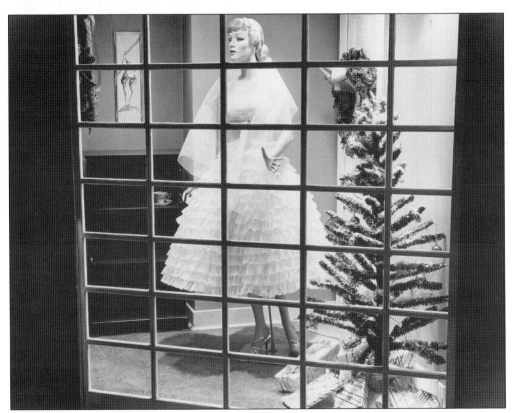

This Hartley's display window featured a bridal Christmas display that was visible to drivers on Adams Street. During the Christmas season, Hartley's employees volunteered their time to create beautiful window displays. (MCHS.)

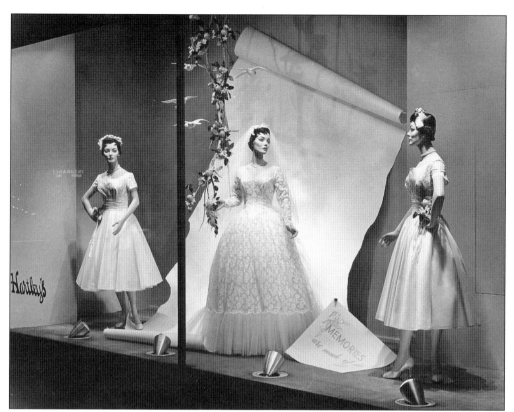

This Hartley's display window shows three bridal gowns. In addition to being recognized for their Christmas displays, Hartley's was well known for their bridal displays. (MCHS.)

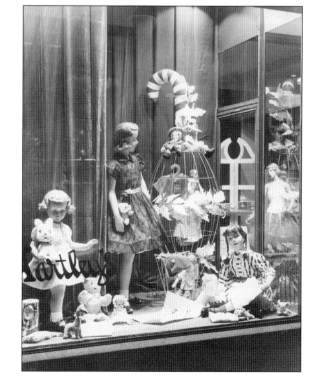

The Christmas windows at Hartley's were always a treat to behold. This display caters to the interests of children—and their paying parents. Hartley's was in business for more than 100 years and remains a symbol of Fairmont's once-vibrant shopping community. (MCHS.)

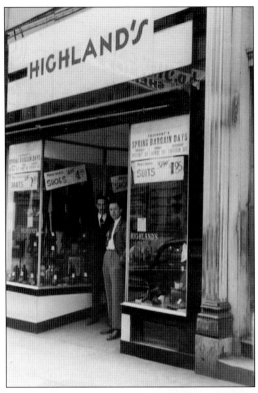

J.E. Patterson was part-owner of Highland's store at 302 Adams Street. J.E.'s son Ralph worked there after returning from Cambridge, England, where he was stationed during World War II. In this image, Ralph Patterson (left) and Bill Haney stand in the store's entryway. Advertisements on the windows for Fairmont's Spring Bargain Days indicate that men's work shoes were on sale for $4.95 per pair. (JoAnn Patterson Nicholson.)

This 1940s image shows, from left to right, Wilma Currey, Peggy Mason, June R., and Edith Currey in front of Hauge's, a popular florist that served downtown and the surrounding areas. (Kim Rhoades.)

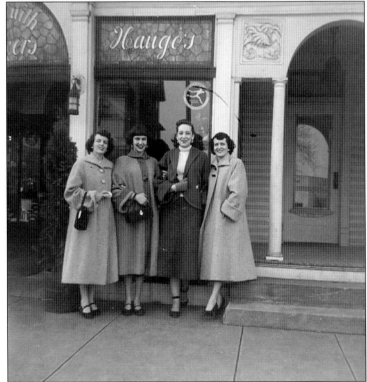

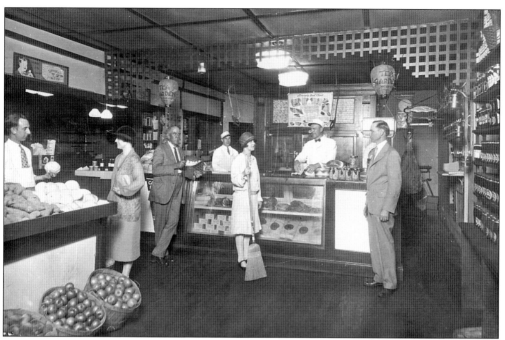

This early-1900s image shows the interior of an unidentified Fairmont grocery store. (MCHS.)

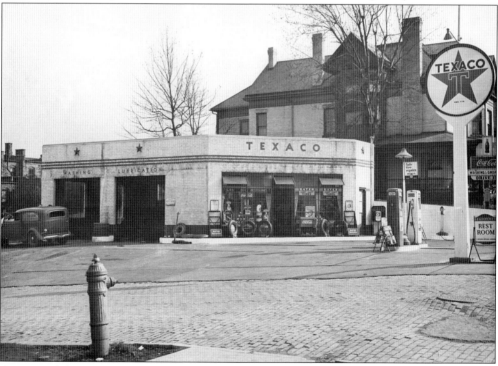

As automobiles gained popularity, streets were paved, and petroleum distribution found its way to Fairmont in the form of filling stations. This c. 1950 photograph shows the Texaco station on the corner of Fairmont Avenue and Fifth Street; this building was owned by J.E. Patterson. (JoAnn Patterson Nicholson.)

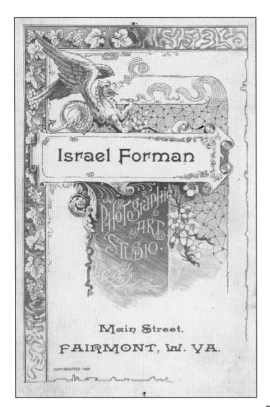

At the start of the 20th century, there were numerous photography studios in Fairmont. This is a placard for one of the local studios, Israel Forman's, which shared the third floor of the Smith and McKinney Building—located at 313–317 Adams Street—with the Knights of the Pythias. (MCHS.)

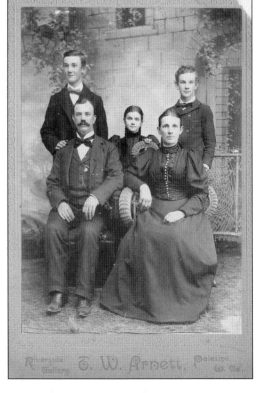

Palatine also had its share of photographers. This photograph of the Wilson family was taken by T.W. Arnett of the Riverside Gallery in Palatine (not to be confused with the T.W. Arnett who owned a hardware store at 329 Main Street). (MCHS.)

This is the back of a photograph advertising C.E. Wilson & Bro. Traveling Photographers that lists the business's permanent address as Palatine. The business was most likely on the northern end of Diamond Street between what was then Franklin Street (now Guffy Street) and the Morgantown and Bridgeport Turnpike (now Morgantown Avenue). (MCHS.)

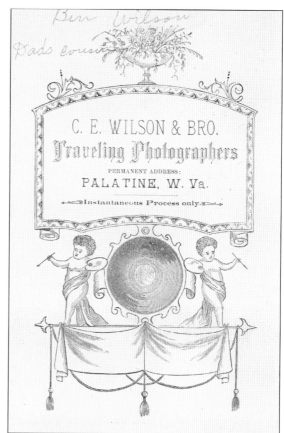

In the image below, three Fairmont gentlemen wait for the photographer to provide them with instruction. The unidentified photographer is at left holding a rope behind his back; the rope was attached to the camera. (MCHS.)

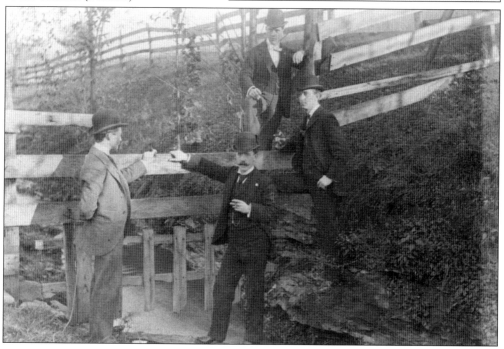

Pictured here are the E.E. Boord house and Boord's Grocery on Benoni Avenue. The sign on the surrey reads, "E.E. Boord Groceries, Fairmont, WV." It appears the photograph was taken on Benoni Avenue looking toward Fifth Street. (Robert Bice III.)

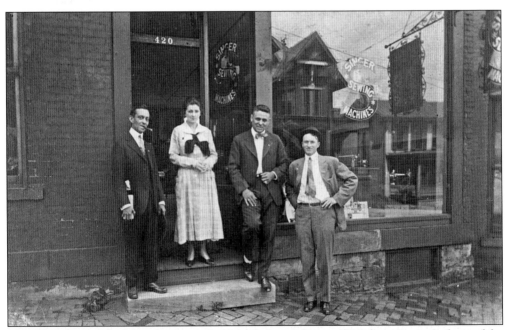

This 1917 photograph shows the Singer Sewing Machines shop at 420 Adams Street. In front of the shop are, from left to right, Thomas B. Throop, assistant manager and salesman; an unidentified woman; Lloyd B. Ganoe; and an unidentified man. (MCHS.)

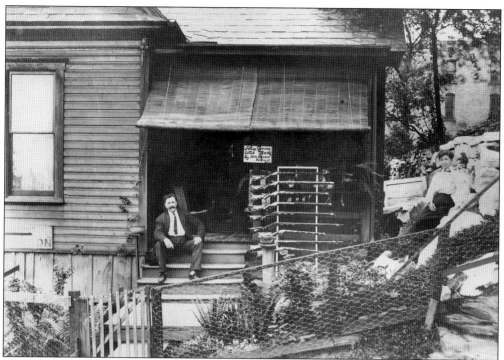

M.M. Benson sits on the front steps of his store as his wife poses atop some rocks at right in this late-19th-century photograph. Benson was a gunsmith in Fairmont, and the sign hanging above the gun rack says, "These guns was made by M.M. Benson, Fairmont, W.Va." (MCHS.)

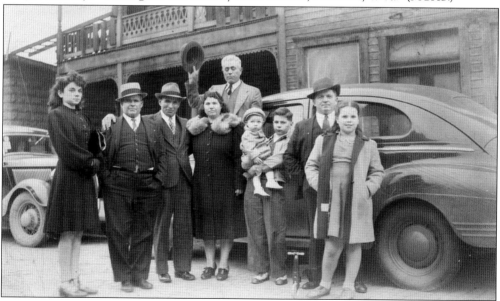

Water Street, on Fairmont's east side, was once home to various business establishments. This photograph taken in front of Rose Finamore's boardinghouse includes, from left to right, Virginia Martello, Frank Merendino, Joseph Merendino, Rose Finamore, Nick Domico (behind Finamore with his hat in the air), Joseph Merendino Jr. (holding Marshall Lupo), Patsy Donofrio, and Carmella Merendino. (Patricia Ann Merendino Greco.)

This 1902 downtown street scene looks up Adams Street from Cleveland Avenue. Several businesses are located on the street, and the streetcar travels between horse-drawn carriages. (MCHS.)

This street scene from the early 1900s looks southwest along Adams Street. Note the old First National Bank of Fairmont building at left; it is now the home of Adams Office Supply. When this photograph was taken, the street was paved with bricks. (MCHS.)

This postcard shows the corner of Adams and Quincy Streets at the "Head of Main Street." The building in the right foreground with the stairs is thought to be the Elks Club. Down the street, the Arnett residence at 421 Adams Street was an example of antebellum architecture featuring first- and second-floor porches. Just past the Arnett resident is the overhead sign for Chisler Hardware, which was located at 413 Adams Street. The Watson Hotel is across the street from Chisler Hardware. (MCHS.)

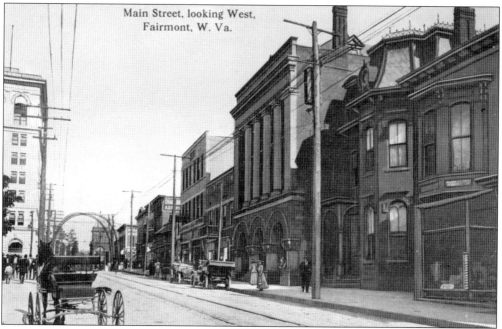

This postcard looks west down Main Street. To the right of the First National Bank building is the Victorian-style cashier's residence, which was remodeled by E.C. Jones in 1917 when the front of the structure was completely covered with a more modern flat, brick facade. A horse and buggy are clearly visible in the left foreground. (MCHS.)

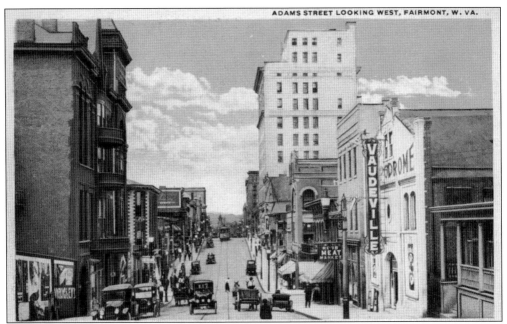

This postcard shows a street scene of Adams Street looking southwest. Note the "vaudeville" signage outside the Blue Ridge Theater, which replaced Chisler Hardware, and the small Robb Meat Market sign just past the theater. (MCHS.)

Between 1840 and 1915, Fairmont had approximately 14 newspaper agencies, including dailies, weeklies, and monthlies, many of which required the services of a horse and wagon to deliver their publications. This photograph shows the storefront and delivery wagon of the *Marion News Agency*. (MCHS.)

Henry C. Sample was the editor and operator of the *Fairmont Press*, which shared the Sample Building at 221 Monroe Street with the Fairmont Printing Company in 1900. (MCHS.)

In 1865, two years after West Virginia was admitted into the Union, the state established the West Virginia Normal School at Fairmont, a private institution dedicated to educating teachers. This school started in the basement of the Methodist Protestant church. In 1867, the facility shown below was erected at 401 Quincy Street, on the corner of Adams Street. (MCHS.)

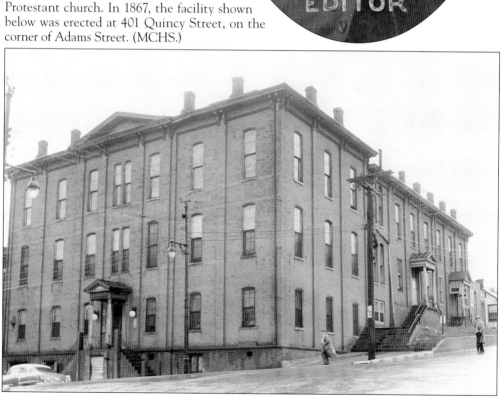

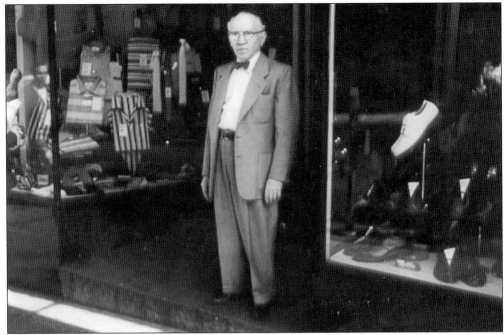

This 1957 image shows Reuben "Rubie" Fink in front of Rubie's Men's Shop, which was located at 306 Adams Street, next to Highland's. In 1926, Fink came to Fairmont from Brownsville, Pennsylvania, and began working with his brother Marvin at the Marvin Fink Store at 323 Adams Street. After 14 years, Rubie opened up his own shop. (Chuck Fink.)

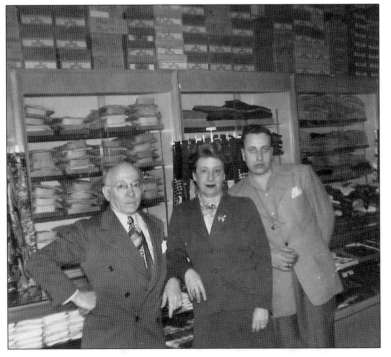

Reuben, Etta, and Ivan Fink are pictured here inside Rubie's Men's Shop. The store was in business from approximately 1940 to 1963; Rubie's wife, Etta, worked as his bookkeeper. A barbershop occupied the space to the left of Rubie's, which had previously been Sherwood's barbershop from 1903 through 1920, and Highland's was to the right. (Chuck Fink.)

Four

QUALITY OF LIFE

As the population exploded to more than 5,000 residents in 1900, it became necessary to secure larger, improved education facilities, healthcare establishments, hotels, and churches. People began to socialize more and joined various societies, clubs, and service organizations, such as the Elks, the Moose, the Eagles, the Lion's Club, the Rotary Club, and the Kiwanis. Postal communication improved, and residents welcomed the arrivals of the telegraph and telephone.

Numerous hotels sprang up in Fairmont, including the Watson, the Fairmont, the Marietta, the Baldwin, the Boyer-Irvine, the Carrico, the Continental, the Fountain, and numerous others. People could now easily travel across the Monongahela River to patronize various businesses. Fairmont also contained numerous confectioneries, cafés, ice cream parlors, saloons, and restaurants. The quality of life in Fairmont improved considerably around the beginning of the 20th century.

Sundays have always been a time for families to gather for food, fun, and merriment. This image shows Louise Martello with three of her children at the family home on Owens Avenue in the early 1940s. From left to right are Eugene and Angelina Martello Endler, Tony Martello, Louise Martello, and Nicholas and Virginia Carmella Martello Palomino. (Patricia Ann Merendino Greco.)

Easter Sunday was an especially important time when families would dress up and spend time together. Here, siblings Joseph (left), Patricia (center), and Carmella Merendino, the children of Frank and Mary "Mimi" Merendino, enjoy their Easter baskets as they sit on a blanket in their yard on Owens Avenue. Note Patricia's cowboy boots as she stands next to a chocolate rooster. (Patricia Ann Merendino Greco.)

The impressive Fairmont Normal School is pictured here under construction at Third Street and Fairmont Avenue. The clock had not yet been installed in the tower. (MCHS.)

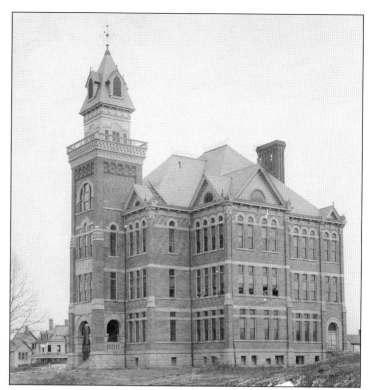

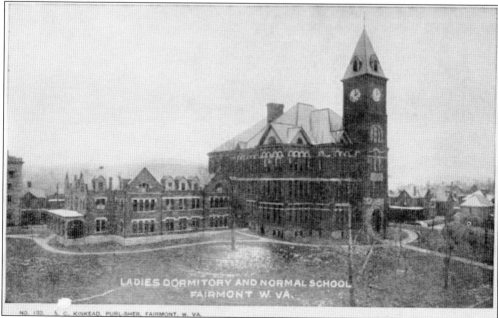

The Fairmont Normal School was located along Fairmont Avenue between Second and Third Streets. It remained at this location from 1893 to 1916. The ladies dormitory is to the left of the main building. The raised mound of earth with a tree growing out of it in the center of the yard was a Native American burial ground that was the inspiration for naming the Fairmont State yearbook *The Mound*. (MCHS.)

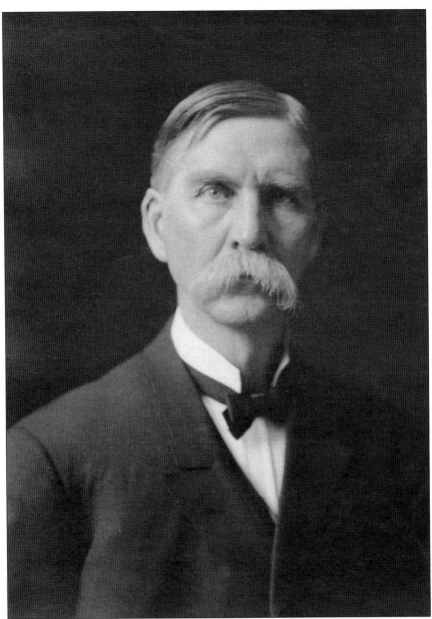

Ulysses Sydney Fleming, a descendant of Fairmont's founding family, was born on August 20, 1851, to Matthew Logan and Mariah Vandervort Fleming. He was the great-grandson of Benoni Fleming—the brother of Boaz Fleming, who owned the farm on which Fairmont was founded. Ulysses grew up with four brothers and four sisters, then married Ella May Heavner and had six children of his own. He taught for three years in country schools in Marion County, then for five years in Beverly and six years in Grafton. He spent six years in Pittsburgh as the publisher of Methodist Protestant Sunday school periodicals and church papers. He then spent seven years as the superintendent of Parkersburg city schools, followed by eight years at Fairmont State Normal School, including three years as principal. He graduated from Pittsburgh Iron City College and Fairmont Normal School and was given an honorary degree by West Virginia University. (MCHS.)

The Methodist Protestant church, known to most as the "Church on the Hill," was located at 418 Quincy Street. The original wood frame structure was built in 1833 on a lot donated by Gov. Francis H. Pierpont's father, Francis Pierpont. The brick church in this image replaced the wood-framed one in 1852. In 1865, the West Virginia Normal School at Fairmont started in this structure's basement. A new church was built in 1897 at 418 Monroe Street. (MCHS.)

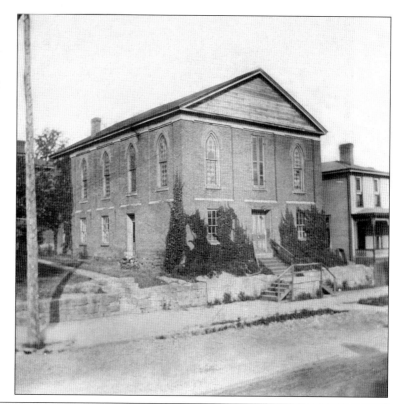

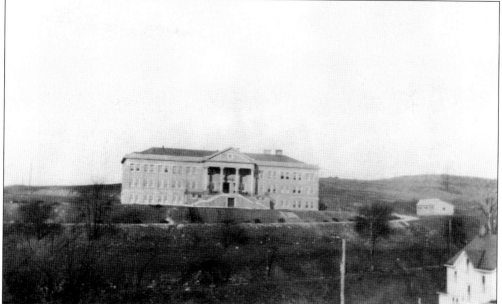

As Fairmont State Normal School's enrollment increased, it began to outgrow its facilities. In early 1917, the school moved from Fairmont Avenue to Locust Avenue. This image shows a view of the Normal School's Woman's Hall, which was built in 1922. This was the second permanent building constructed on the campus and was renamed Morrow Hall in honor of Nancy R. Cameron Morrow, who was a teacher, assistant principal, and principal from 1882 to 1890. (MCHS.)

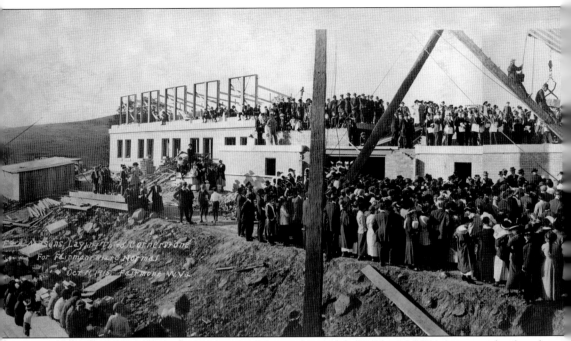

This photograph was taken at the laying of the cornerstone for Hardway Hall on property developed on a dairy farm owned by Moses Lamb in 1917. In 1931, the West Virginia legislature changed the institution's name to Fairmont State Teachers College, a title that changed again in 1944 to Fairmont State College. In 2004, the school was renamed Fairmont State University. Fairmont

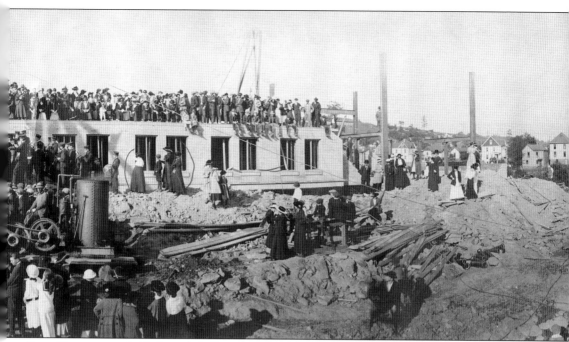

State Community & Technical College (now Pierpont Community & Technical College) was founded in 1974 as part of Fairmont State College; the school continues to offer educational opportunities for "non-traditional" students like its namesake, Francis H. Pierpont, who worked as a tanner and a bricklayer while putting himself through school. (MCHS.)

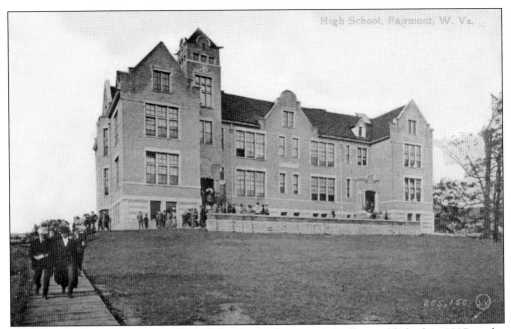

This postcard shows Fairmont High School, which was originally established in 1897 at the Second Ward Building and relocated in 1905 to the present-day location of the Fifth Street Gym. After the new Fairmont Senior High School was built in 1928, this building (the old high school) became the junior high, which closed in 1963. (MCHS.)

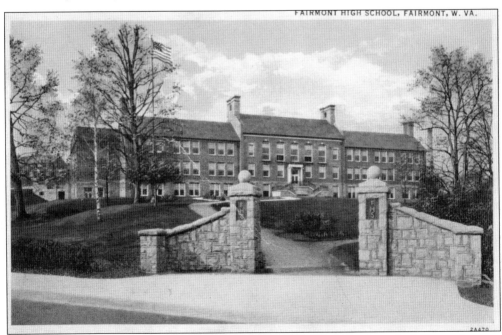

FAIRMONT HIGH SCHOOL, FAIRMONT, W. VA.

This postcard depicts the Fairmont Senior High School, located at 1 Loop Park Drive, that was built in 1928 and opened in 1929. Prior to this school's opening, students attended Fairmont's only high school at the time, which was located on Fifth Street (and is pictured in the image at the top of this page). (MCHS.)

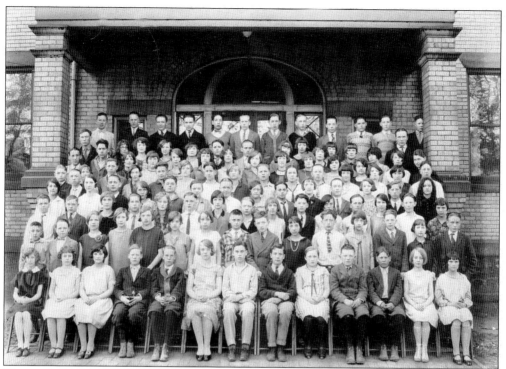

This c. 1925 image shows students at Central (First Ward) School at 316 Columbia Street in Palatine's east side. This school eventually closed and consolidated its classes into various other local schools. This building was later occupied by the OP Shop. (MCHS.)

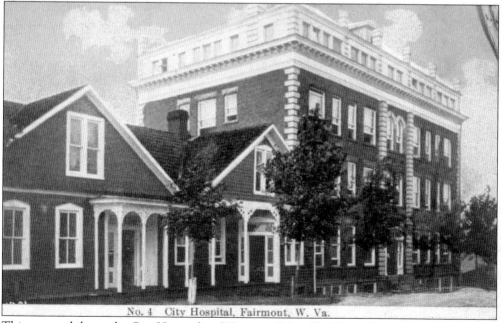

No. 4 City Hospital, Fairmont, W. Va.

This postcard shows the City Hospital and Training School for Nurses located at 110 Merchant Street in Palatine. That location has been home to several businesses in recent years, including an apartment building, a school-supply store, and a restaurant and bar. (MCHS.)

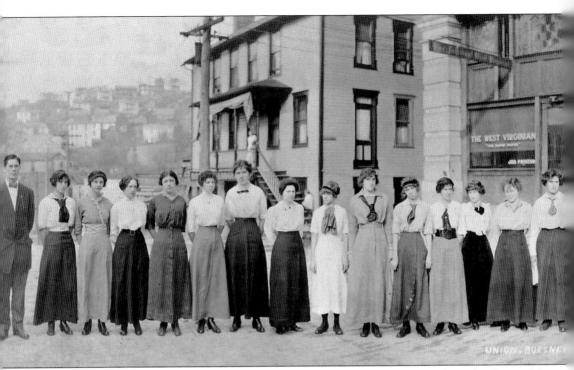

In 1930, several businesses occupied the 300 block of Monroe Street, primarily in the George M. Jacobs building, including the *West Virginian* newspaper office, the Fairmont Building and Loan Association, Union Business College (which occupied the entire fifth floor of the building), and Holbert Brothers Insurance. Jacobs spent $18,000 purchasing the lot for this building and

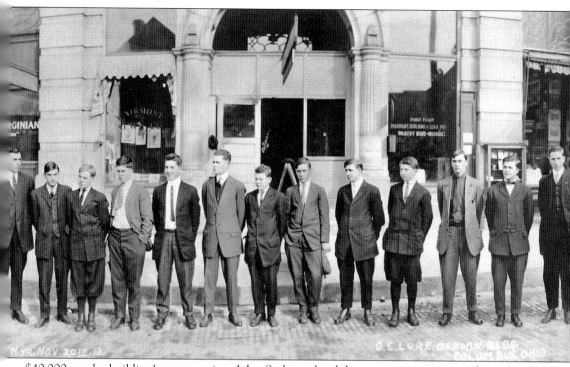

$40,000 on the building's construction. John Stokes, who did some stone-carving work on the Congressional Library in Washington, DC, also did the carving work on this building. This pre-1930s photograph shows students from the Union Business College lined up in front of the Jacobs building. (MCHS.)

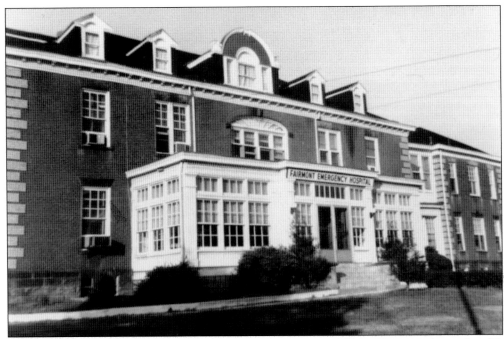

The Fairmont Emergency Hospital, also known as Miner's Hospital No. Three, was located at 401 Guffy Street. It was built in 1899 in the old Watson cow pasture that served as Palatine's first football field. In January 1980, the original structure was replaced with a new building; it was eventually renamed the John Manchin Sr. Health Care Center. (Herschel and Mary Walls family.)

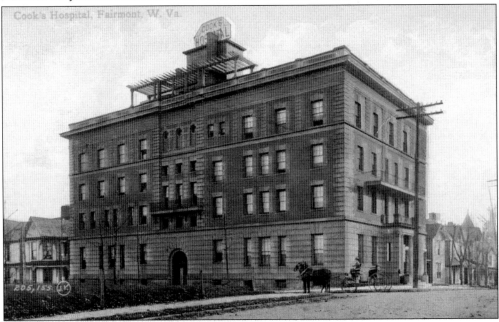

This early-1900s photograph shows Cook Hospital, the precursor to Fairmont General Hospital, which was located on the south side. Founder Dr. John R. Cook, the company doctor for the Montana and New England mines, purchased the J. Walter Barnes property on Gaston Avenue and Second Street around 1901 and built this four-story, 100-bed hospital there in 1903. (MCHS.)

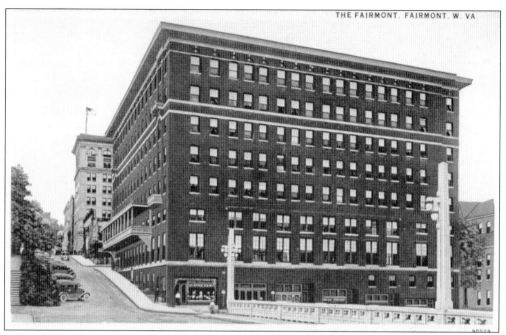

Around 1900, Fairmont was thriving, and numerous hotels catered to guests and employed locals. This c. 1920 postcard features the 125-room Fairmont Hotel at 200 Jefferson Street on the corner of Washington and Jefferson Streets. This hotel had numerous ballrooms, shops, and nightclubs. The Town Club was on the mezzanine level of the hotel. (MCHS.)

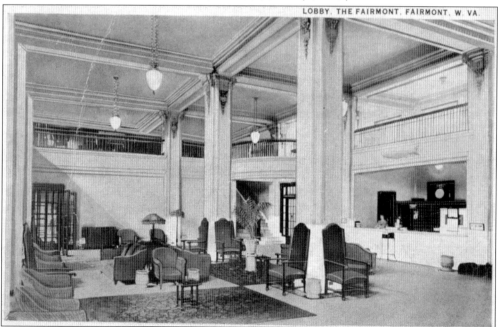

The is the lobby at the Fairmont Hotel. In the early 1800s, the future site of the hotel contained one- and two-story buildings and residences. An estimated 10,000 people attended the grand opening on July 16, 1917. By August 1919, the popularity of the hotel led to a two-floor addition being constructed to provide 68 more rooms. (MCHS.)

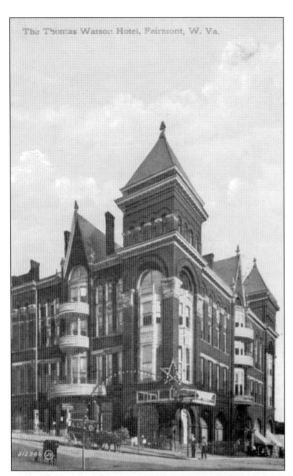

The Thomas Watson Hotel, Fairmont, W. Va.

Another popular hotel was the Thomas Watson Hotel at 402–408 Adams Street on the corner of Madison Street. It opened for business on January 24, 1895, and hosted a variety of social events enjoyed by the local public and guests from several surrounding states. In 1907, proprietor J.W. Conaway charged $2 per room and an additional $2.50 if it had an attached bath. (MCHS.)

Built in 1847 by James Burns, Skinner's Tavern (below) was one of the better-known hotels in Fairmont. It was located at 104 Cleveland Avenue at the foot of Madison (Bridge) Street and directly across from the B&O Railroad depot. Charlie Skinner and Benjamin Williams were proprietors of the tavern at different times. (MCHS.)

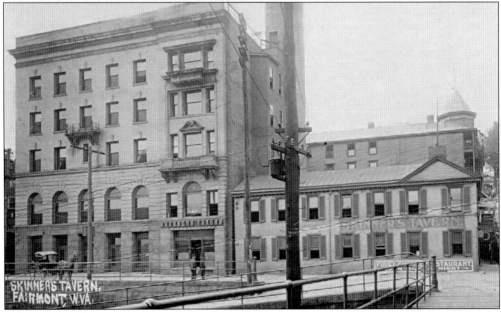

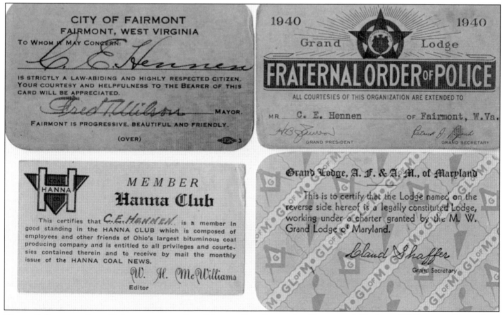

1912 | Complimentary | 1912

FAIRMONT HUNT CLUB'S

MEETING, JULY 4, 5, 6

Pass _____

Valid for Admission Grand Stand

This Card Must Be Signed By

General Manager.

In the early 1900s, several civic and fraternal organizations were active in Fairmont, including the Elks, the Moose, the Eagles, the Lion's Club, the Rotary Club, and the Kiwanis. This is a 1912 membership card for the Fairmont Hunt Club. (MCHS.)

CITY OF FAIRMONT
FAIRMONT, WEST VIRGINIA
To Whom It May Concern:

IS STRICTLY A LAW-ABIDING AND HIGHLY RESPECTED CITIZEN. YOUR COURTESY AND HELPFULNESS TO THE BEARER OF THIS CARD WILL BE APPRECIATED.

_____ MAYOR.

FAIRMONT IS PROGRESSIVE, BEAUTIFUL AND FRIENDLY.

(OVER)

1940 | Grand | Lodge | 1940

FRATERNAL ORDER OF POLICE

ALL COURTESIES OF THIS ORGANIZATION ARE EXTENDED TO

MR. C. E. Hennen of Fairmont, W.Va.

GRAND PRESIDENT GRAND SECRETARY

MEMBER
Hanna Club

This certifies that C.E. HENNEN is a member in good standing in the HANNA CLUB which is composed of employees and other friends of Ohio's largest bituminous coal producing company and is entitled to all privileges and courtesies contained therein and to receive by mail the monthly issue of the HANNA COAL NEWS.

W. H. McWilliams
Editor

Grand Lodge, A. F. & A. M., of Maryland

This is to certify that the Lodge named on the reverse side hereof is a legally constituted Lodge, working under a charter granted by the M. W. Grand Lodge of Maryland.

Claud Shaffer
Grand Secretary

One of these various Fairmont membership cards is from the Fraternal Order of Police, and another attests to the credibility of character of a resident of the friendly city. It mentions that the bearer is a law-abiding and respected citizen and states, "Your courtesy and helpfulness to the bearer of the card will be appreciated." (MCHS.)

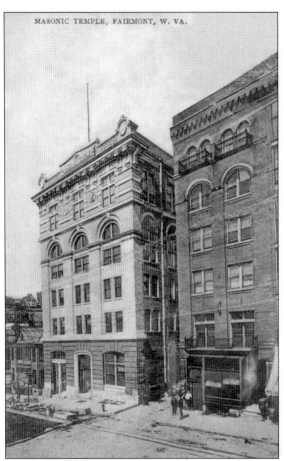

This 1906 postcard shows the Masonic temple at 316–320 Jefferson Street. At the time the building was dedicated in April 1906, the oldest member of the lodge, E.C. Kerr, recalled that when he joined in 1850, they met on the second floor of a building at 110 Adams Street. (MCHS.)

This c. 1920 postcard shows the Fairmont Field Club. The clubhouse was established in 1912 and is located at 1709 Country Club Road. Although this structure was damaged by fire in April 2008, it has since been rebuilt. (MCHS.)

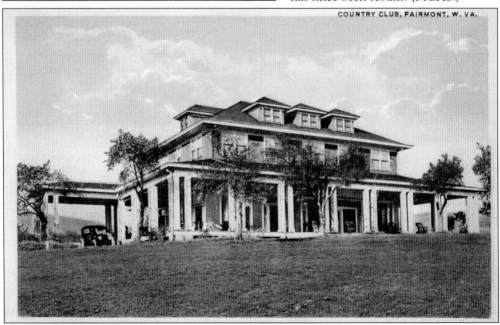

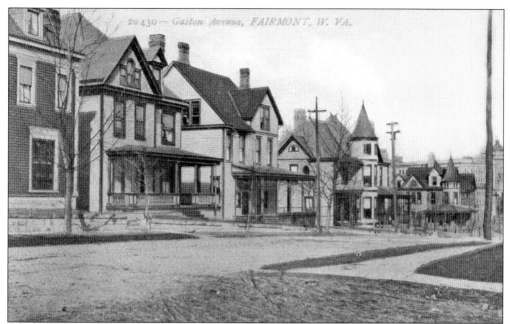

Through the efforts of the Fairmont Development Company, the south side of Fairmont was surveyed and platted into residential and business sectors. In 1909, the majority of businesses stretched from First to Thirteenth Streets along the B&O Railroad. This postcard, postmarked 1913, shows the Gaston Avenue area in the early 1900s. (MCHS.)

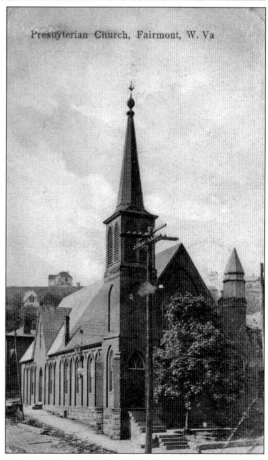

According to Allison Sweeney Fleming, around 1833, the original Presbyterian church and cemetery were constructed on land donated by Boaz Fleming at the corner of Jefferson and Adams Streets (in or near the present-day location of Wesbanco Bank). According to Debra McMillan, the First Presbyterian Church featured in this postcard was built in 1879 at the corner of Jefferson and Jackson Streets at a cost of $3,000. A new church was constructed on the same site in 1916; it still stands today. (MCHS.)

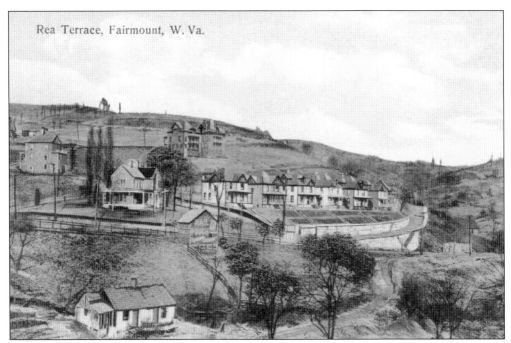

This postcard captures the neighborhood of Rea Terrace around 1908. The fork in the road was part of the path that Confederate general William E. "Grumble" Jones's calvary traveled during their 1863 raid. The lower portion of the road winds around toward Coal Run Hollow. (MCHS.)

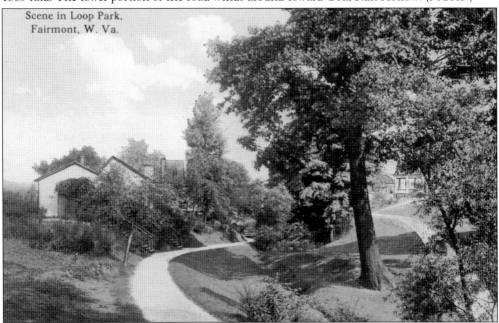

In 1928, Fairmont Senior High School was moved to a portion of the land that was called Loop Park. It was so named because the streetcar system looped around the park for the convenience of those traveling to and from the park. Loop Park was a popular gathering spot; it had winding walking paths that encouraged people to relax and meander. This postcard shows a scenic view of the park. (MCHS.)

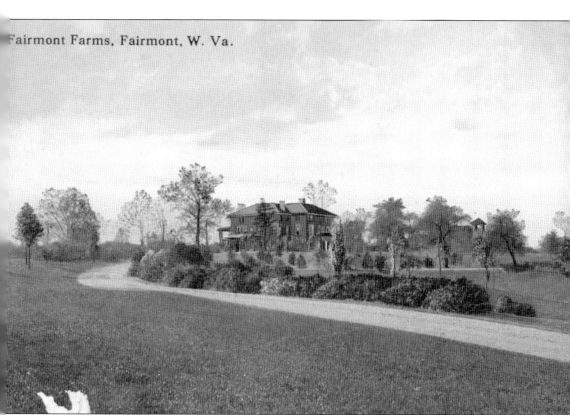

One of the more affluent areas in Fairmont in the early 20th century was developed by James Otis Watson on land once owned by Alexander Fleming. Watson was born on May 17, 1815, in Benton's Ferry and was the oldest son of Thomas and Rebecca Haymond Watson. He was homeschooled. His business interests included a store, a cattle trade operation, and a brick factory. He was instrumental in organizing the construction of the suspension bridge that connected Fairmont to Palatine in 1852. Along with Francis H. Pierpont, he opened a coal mine and later served as a delegate to the 1861 Wheeling convention that led to the founding of West Virginia. With his son-in-law Aretas Brooks Fleming, Watson opened the Gaston coal mine in 1874 and the Montana Mine in 1886, followed by others along the West Fork River. This postcard features Watson's farm and homestead, La Grange, which was later remodeled by his heirs and then referred to as Fairmont Farms. (MCHS.)

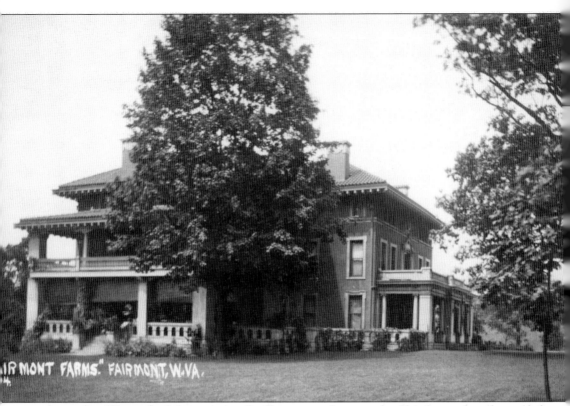

IR MONT FARMS." FAIRMONT, W.VA.

James Otis Watson built his mansion, La Grange, on the grounds of his farm, where he resided until his death on June 12, 1902. He married Matilda Lamb in 1841, and the couple had ten children. His son Clarence Wayland was an 1886 graduate of the Fairmont State Normal School and, in 1893, Clarence joined his father and brothers in the family's mining enterprises. In 1894, Clarence married Minnie Lee Owings and moved into his father's mansion, La Grange, which he remodeled in the Spanish Mission style, with a stable for his world-class horses, and renamed Fairmont Farms. In 1901, Clarence combined the Watson mining properties with others in the Fairmont field to form the Fairmont Coal Company, which operated 28 mines and had 6,067 employees. In 1903, he orchestrated the merger of Fairmont Coal Company with Consolidation Coal Company of Maryland. He was named president of the company at the time of the merger. Clarence served in the US Senate from 1911 to 1913 and was a lieutenant colonel in the US army during World War I. (MCHS.)

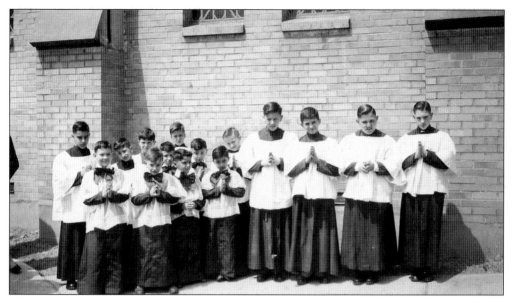

Altar boys, some of whom went on to become lawyers, police officers, and firemen, stand outside of St. Joseph's Parish at the corner of Robinson and Bennett Streets. Coal mine subsidence caused a great deal of damage to the inside of this church, and the Catholic diocese eventually elected to tear it down. (Patricia Ann Merendino Greco.)

Members of the Methodist Protestant church at 216 Monroe Street pose in front of the church around 1900. The church was originally located at 418 Quincy Street and known as the Church on the Hill, but a new church was built in 1896. The fire department once used the Monroe Street church's belfry to announce fires. (MCHS.)

This 1897 picture shows the First Methodist Episcopal Church choir. Several well-known members of the community sang in this choir, including Georgia Weathermax, Blanche Shinn, Madge and Allie Sample, Blanche Fitch, Elizabeth Haymond, and Drury Hamilton. (MCHS.)

The settlement house movement began in the late 1800s to help assimilate and ease immigrants into the labor force. Many provided social services, homeless shelters, public kitchens, day cares, and public baths. This photograph shows the Engle Settlement House on Maple Avenue, which was used by the First Methodist Episcopal Church around 1930. (MCHS.)

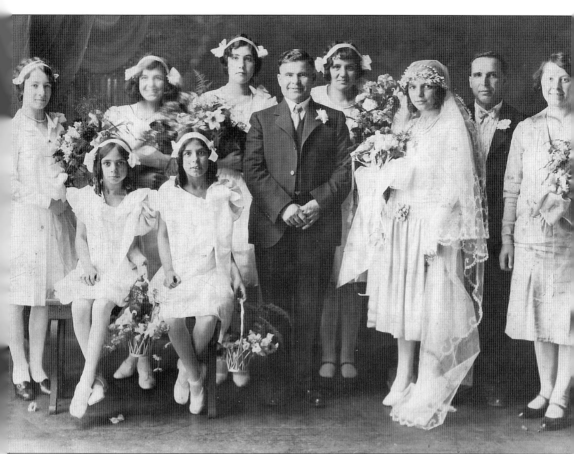

Weddings are wondrous and beautiful events. This April 29, 1929, photograph shows the wedding party of Frank Merendino and Mary Elizabeth Martello, which included, from left to right, (seated) Virginia and Evangeline Martello; (standing) unidentified, Tessie Cossi, unidentified, Frank Merendino, Miriam Kittle, Mary Elizabeth Martello, and Sam and Minnie Girard. Before the wedding, Frank was employed at a tannery in Ellamore and Mary lived in Norton, West Virginia, with her family; her father, Lease Nunziato Martello, worked in the coal mine there. After the wedding, the newlyweds moved to Fairmont so Frank could work at the Domestic Coke Corporation, a wholly owned subsidiary of Standard Oil of New Jersey, which was built in 1918 and was the corporate predecessor to the Exxon Corporation. The Domestic Coke plant, also known as the Fairmont Coke Works, was one of only a few Fairmont factories that hired Italian immigrants at the time. It was later purchased by Sharon Steel; in 1996, the Environmental Protection Agency listed the Fairmont Coke Works on its National Priorities List of Superfund Sites. (Patricia Ann Merendino Greco.)

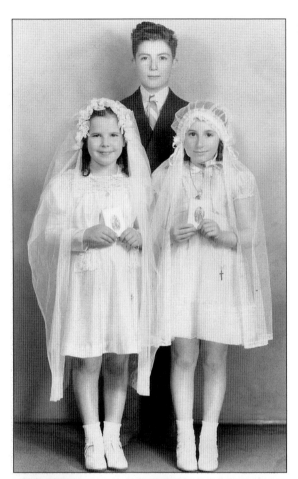

First communions were celebrated events in the Catholic community. This c. 1943 photograph shows Carmella Merendino (left), her friend Lucille DeBate (right), and DeBate's brother Michael. (Patricia Ann Merendino Greco.)

Levi Brooks Harr was a prominent real estate broker in Fairmont for nearly 50 years. One of his residences—1520 Morgantown Avenue—is shown below, where Harr is pictured with two children and a roadster. (MCHS.)

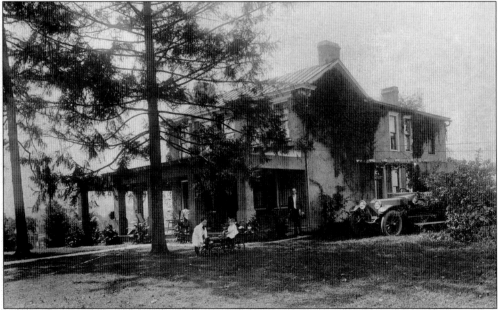

The location of Fairmont's first post office is often debated, as locals disagree about whether it was in Polsley's Mills, at the Haymond homestead on Palatine Hill, or in Barnesville. There is also disagreement about who the first postmaster was. This 1914 photograph shows the post office when it was on Monroe Street; this building now houses Marion County Public Library. (MCHS.)

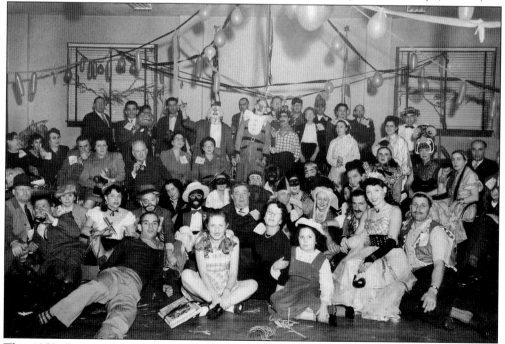

This 1950s Purim celebration was most likely held at the Temple Beth El in Fairmont. Many of those pictured are dressed in costume. In the second row, just left of center, Rubie Fink is in blackface and wearing glasses and a hat. (Chuck Fink.)

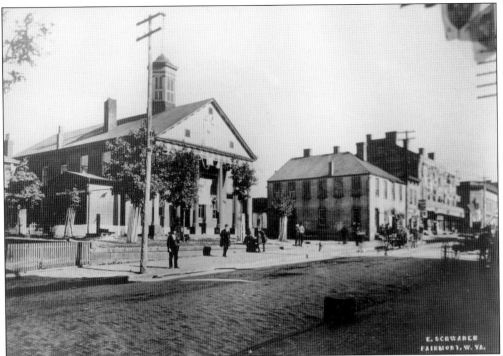

The Mountain City Hotel was once located on the current site of the Marion County Courthouse and sat where a war memorial was located. It was sold by Matthew Fleming's heirs to provide the land for the new courthouse in 1897. This c. 1880 photograph shows the bricks used for the road. The Mountain City Hotel is to the right of the old courthouse in this image. (MCHS.)

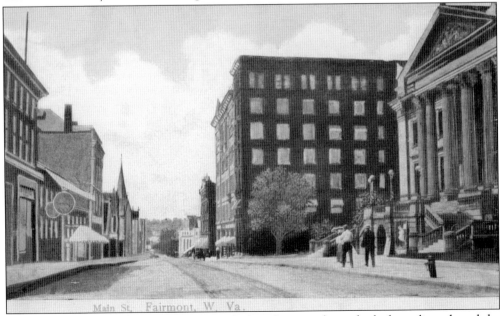

This 1908 photograph shows Adams Street before electric poles and telephone lines dotted the city's skyline. The new courthouse is at right. In 1912, the jailer's/sheriff's residence was built at 215 Adams Street. (MCHS.)

Five

GOVERNMENT FOR THE PEOPLE

As Fairmont's expansion continued during the mid-1800s and into the early 1900s and development, commerce, and industrialization took hold, the city realized an increased need for government services such as a police department, a fire department, street paving, a water system, and more. Written history indicates that the courthouse that was built in 1844 at a cost of $3,150.75 was no longer serving the people, because it was dilapidated and the space was no longer large enough to keep up with the growing needs of the populace.

Citizens voted down a bond to increase taxes to pay for a new building, so some members of the community reportedly took matters into their own hands. According to Debra McMillan, "On the night of January 12, 1897, a group of about eighty men gathered and lit into the old place with crow bars, axes, and mattocks, doing much damage to the walls, roofs and floors." Prominent citizens were apparently in attendance, and toasts were given and speeches delivered in support of what they had planned. Plans were eventually drawn up for a new courthouse, and the Mountain City Hotel was demolished to make room for it. Construction on the stone, brick, steel, and concrete structure was completed in 1900.

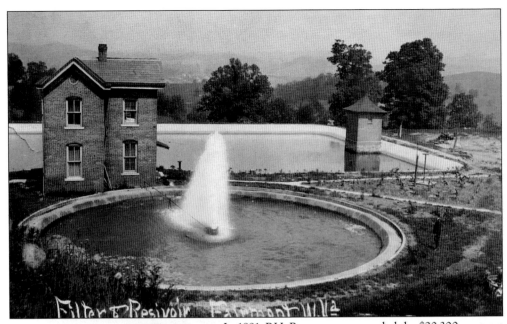

Filter & Resivoir Fairmont W. Va.

In 1891, P.H. Bennett was awarded the $20,300 contract to build Fairmont's water system. It was constructed after then-mayor Thomas "Parks" Fleming loaned the city the money for the project. A pump station was located at the foot of Jefferson Street, and the pipelines extended up to Hamilton Hill. The image above shows the filtration plant at Morris Park. (Robert Bice III.)

According to written family history, Col. Isaac Holman, a short, stocky man of Dutch descent, came to West Virginia from Pennsylvania and settled on 700 acres of land near present-day Colfax. He became the sheriff of Marion County during the Civil War. (MCHS.)

Cal Conaway was the sheriff of Marion County from 1913 to 1917. He was the first sheriff to reside in the sheriff's home at 215 Adams Street. Some of Conaway's descendants also held the office, including Thomas P. Conaway, W.W. Conaway, Frank Conaway, and Robert H. Tennant. (MCHS.)

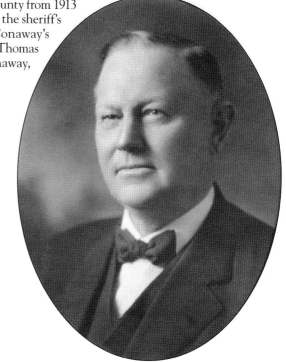

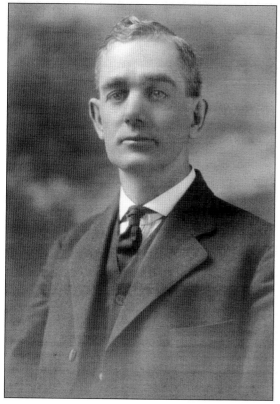

James D. Charlton, born on October 9, 1867, was the third son of Benjamin F. and Elizabeth Wallace Charlton, and was raised in Mannington, West Virginia. He was the sheriff of Marion County from 1920 to 1924. He died in Wierton, West Virginia, on November 9, 1952. (MCHS.)

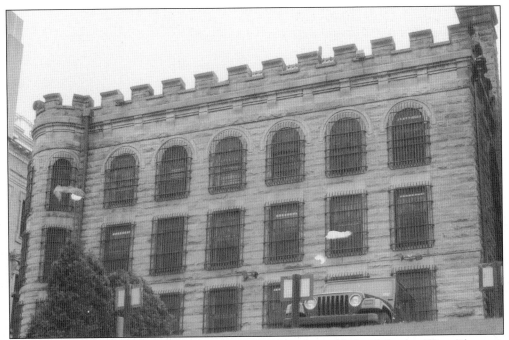

The Marion County jail opened on March 12, 1912. Constructed behind the sheriff's residence, it is not visible from Adams Street but can be seen from Porter Alley. At the time of construction, it could accommodate 100 prisoners. The once-dormant structure was restored for use as the county jail on January 16, 2013. (MCHS.)

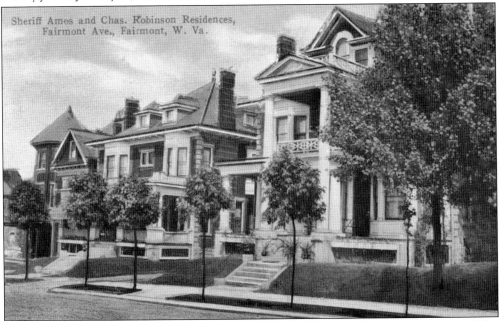

The Fairmont Development Corporation (FDC) was instrumental in the expansion of the south side of Fairmont from First through Fourteenth Streets. Fairmont Avenue was the primary thoroughfare, and many residences were along that road. This photograph shows the Fairmont Avenue homes of sheriffs Amos and Charles Robinson in the early 1900s. (MCHS.)

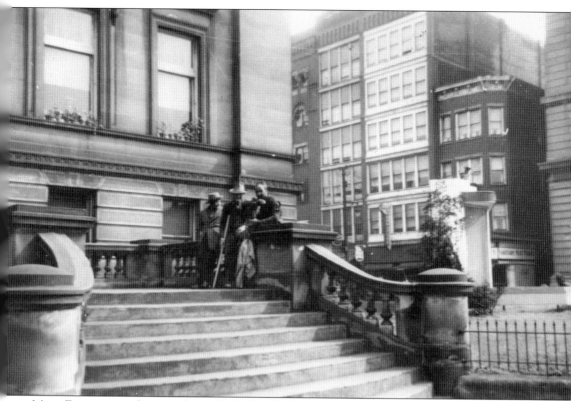

Many Fairmont residents might recall the Hughes boys— Zach, Bert, Alphie, and Russell—from Uzztown. Uzztown Road is located at the end of Washington Street traveling east, and if a traveler follows it along the Monongahela River and B&O Railroad, that traveler will arrive at Buffalo Creek near Bellview. According to Allison Sweeney Fleming, Uzztown was the general area at the old "Y" at the mouth of Buffalo Creek. It was at this location that Fleming notes that they "had our circus ground especially for those shows that traveled by train." The Hughes boys lived somewhere along the Uzztown road and walked to the courthouse on Adams Street, where they spent their days "hanging out" and living off of the kindness of the townspeople. Oral history claims that many city employees would help clean the boys and feed and clothe them. This photograph, featuring three of the Hughes boys, was taken on the courthouse steps facing Adams Street. (MCHS.)

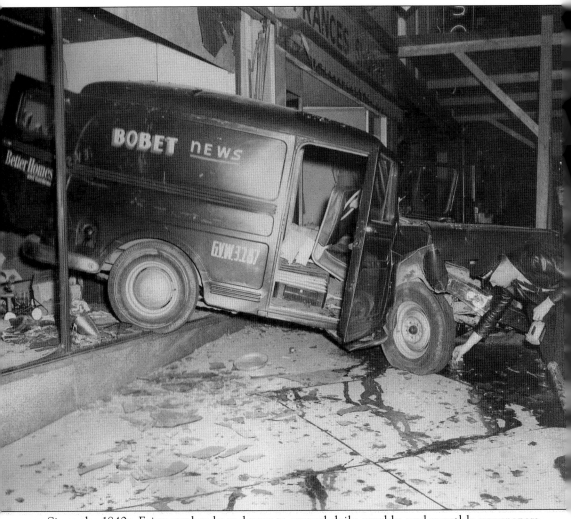

Since the 1840s, Fairmont has been home to several daily, weekly, and monthly newspapers, including several from the mid-to-late 1800s such as the *Marion Pioneer*; the *Baptist Recorder*; the *Democratic Banner* (which was later the *True Virginian* and then the *Trans-Allegheny Advertiser*); the *Fairmont Republican*; the *Methodist Protestant Sentinel*; the *Fairmont National*; the *Vedette* (which was later the *West Virginian* and then merged with the *Fairmont Times* to become the *Times West Virginian*, which still serves the area); the *Liberalist*; the *Fairmont Index*; the *West Virginia Real Estate Journal*; and the *Normal School Daily*. Post-1915 publications included the *Fairmont Times*, the *Fairmont West Virginian*, and the *Fairmont Free Press*. This 1952 photograph shows the scene of an accident caused when driver Peter Wharton crashed the *Bobet News* truck into a Hartley's Department Store display window on Adams Street. (Fairmont Police Department.)

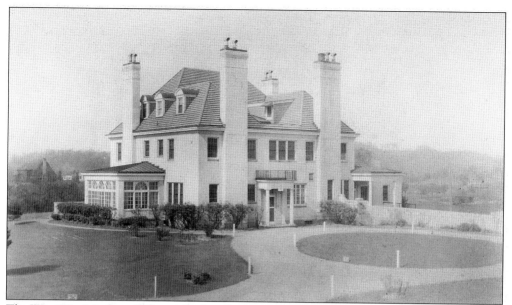

The West Virginia State Police is the fourth-oldest state police agency in America. Interestingly, when confronted with a manpower shortage, an experimental teletypewriter system was operated between headquarters and Fairmont's Company A in March 1934. The success of this test led to the gradual expansion of the state police teletype network. This photograph shows the police barracks in Fairmont. (MCHS.)

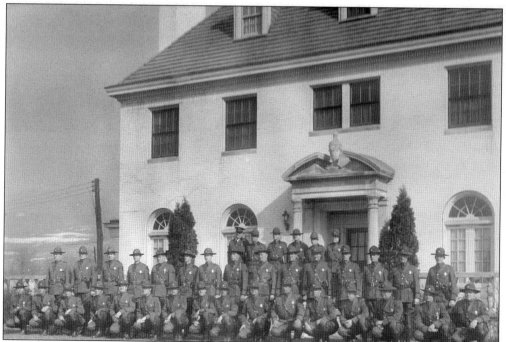

In 1934, the West Virginia State Police field forces consisted of Company A in Fairmont and Company B in Charleston. Company A operated 15 substations, protecting 31 northern counties, and Company B operated 16 substations in the state's 24 southern counties. In this image, Company A stands in front of the barracks in Fairmont. (MCHS.)

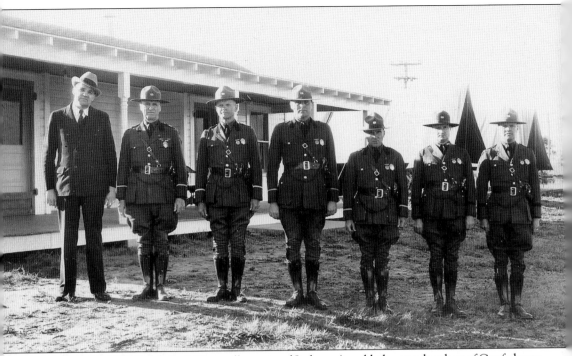

On June 29, 1919, Gov. John J. Cornwell appointed Jackson Arnold, the grandnephew of Confederate general Thomas "Stonewall" Jackson, as the first superintendent of the Department of Public Safety. The established guidelines for the hiring of personnel required that troopers' conduct reflect positively on the state. As such, only men of good character, tact, and intelligence who were capable of maintaining a careful neutrality in all official dealings were favorably considered in the selection process. In July 1919, Sam Taylor was the first trooper hired; by November, there were 121 men on board. Troopers were most often charged with quelling the unrest between striking miners and their operators. In 1925, a state police undercover task force came to the Fairmont area to investigate the deaths of 151 mine workers. The investigation led to the arrest of individuals who were hiding in Newark, New Jersey, and Brooklyn, New York, and one individual who was caught carrying weapons and ammunition across state lines. The superintendent and officers of Fairmont's Company A are pictured here in 1935. (MCHS.)

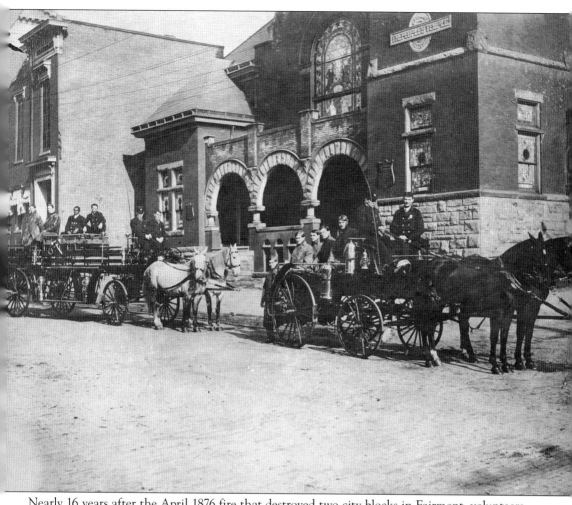

Nearly 16 years after the April 1876 fire that destroyed two city blocks in Fairmont, volunteers organized a fire department named the Mountain City Hose Company. Prior to the establishment of the volunteer fire department, businesses and residents employed the bucket brigade method, passing buckets of water down a line from person to person to douse a fire. Construction began in 1909 on the Central fire station at 211 Monroe Street, and it opened in 1915. It was originally built to house horse-drawn apparatuses—the hose wagon, the ladder wagon, and the fire chief's buggy. In 1913, Fairmont bought the city's first motorized apparatus: a new car for Okey Watkins, who was the fire chief at the time. In December 1914, the city purchased Fairmont's first fire truck, which had a fire pump and carried ladders. This photograph shows the hose wagon and firefighters atop the hook-and-ladder wagon as the vehicles were parked on Monroe Street. This photograph is now on display at the Fireside Café, which is owned by Mark and Monica Delbrook, on Adams Street. (Mark and Monica Delbrook.)

The Grand Army of the Republic (GAR) was a fraternal Union veterans' organization formed at the close of the Civil War. It was organized based on three objectives: fraternity, charity, and loyalty. In 1890, the GAR counted more than 400,000 members nationwide. One of the better-known endeavors of the GAR was the group's fund that offered relief to needy veterans, widows, and orphans. This fund was used for medical, burial, and housing expenses, and for purchases of food and household goods. The GAR helped to arrange loans, and sometimes the veterans found work for the needy. The badges worn by some of the GAR members in this photograph identify them as Knights of the Maccabees (known as Maccabees after 1914), who were instrumental in providing benefits to widows, orphans, and sick veterans. (MCHS.)

Here, Grand Army of the Republic veteran Nuzum Wilson (seated, center) is surrounded by his sons. They are, from left to right, (seated) Frank and Willis; (standing) Santford, Larenza, Charles, and Clinton. (MCHS.)

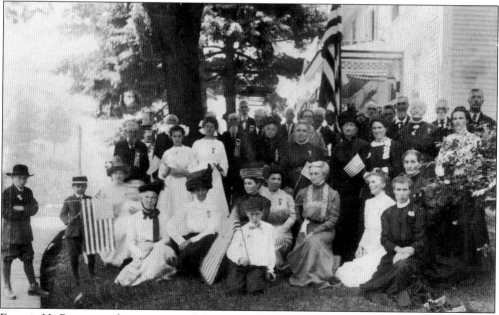

Francis H. Pierpont, the governor of the Restored State of Virginia and a Fairmont resident, requested that Capt. Perry G. West travel through West Virginia to recruit men to enlist in the Capital Guard in Wheeling. This 1880s reunion photograph taken at West's homestead shows the men who served with him, along with their wives and families and various dignitaries. Harriett B. Jones, the first female physician in the state, is also present. (Dora Grubb.)

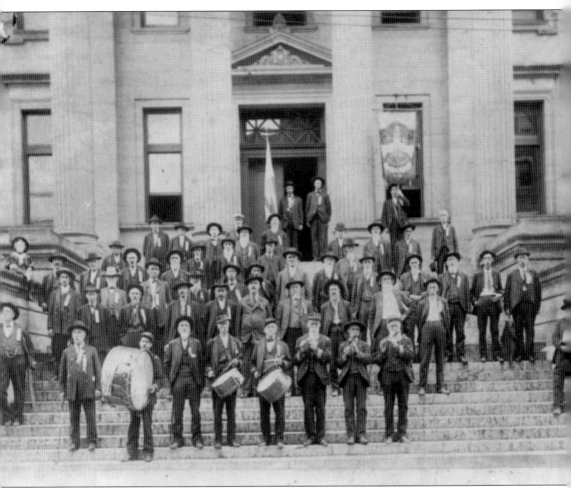

This 1905 photograph taken on the steps of the Marion County Courthouse shows a reunion of the GAR Civil War veterans in Mead Post No. 6. Benjamin Jenkins is on the far right, and Capt. Thomas A. Maulsby, who was wounded in the Battle of Martinsburg, is on the far left (on crutches). Maulsby was the captain of Battery F (formerly Company C of the 6th West Virginia Infantry). Captain Maulsby was known for his heroism in the Battle of Martinsburg. According to the West Virginia Encyclopedia, the West Virginia chapter of the GAR had more than 3,000 members in 1889. (MCHS.)

Six

TRANSPORTATION

Transportation in and around Fairmont did not dramatically improve until the invention of mass transit and electricity around 1900. Before those innovations and the railroad, people traveled by stagecoach, carriage, or riding horse—no matter where they were going or how they were traveling, a horse was involved.

The city and state constructed various sizes, shapes, and textures of bridges—including wood, iron, and concrete—for the transportation of streetcars, railroad cars, pedestrians, horses and buggies, and, eventually, automobiles. Travelers navigated waterways on a regular basis, provided that water levels were not too low. After Thomas "Parks" Fleming oversaw the paving of the first road, advancement continued in this area as construction workers fashioned thoroughfares out of pavers (interlocking precast pieces of concrete) or brick, at first, and eventually a form of asphalt.

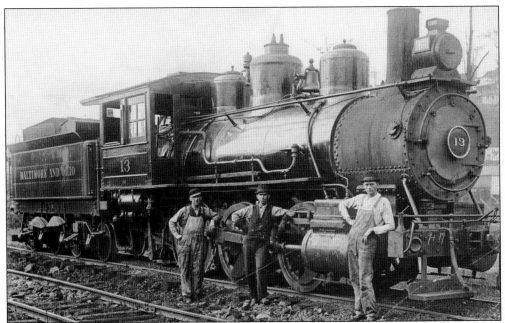

This 1920 photograph of a B&O train engine was taken at Consolidated Coal Company's New England mine in the Watson community. Pictured here are engineer William Merrifield (left), Charley Hawkins (center), and Dale Thompson. (MCHS.)

This 1905 photograph shows a section gang at the east end of the Fairmont, Morgantown & Pittsburgh (FM&P) Bridge looking toward Fairmont. At the time, the railroad had been completed as far as Morgantown. A section gang—typically six men—maintained a section of railroad track that was either four to five miles long (main line) or 10 to 12 miles long (branch line). This structure was later repurposed as a pedestrian footbridge on the Mon River Rail-Trail. (MCHS.)

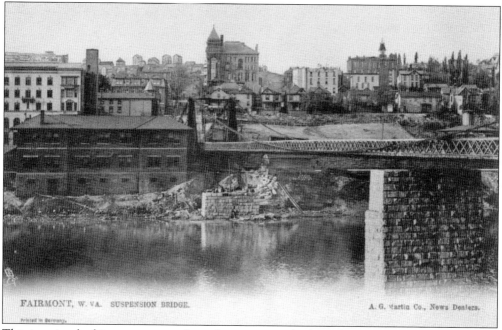

This is a view looking east to west from the suspension bridge. The Watson Hotel, Washington Street, the building housing the West Virginia Normal School, and the B&O Railroad depot are all visible in the background of this image. Thomas Hennen and Mr. McKinney took tolls at the bridge. (MCHS.)

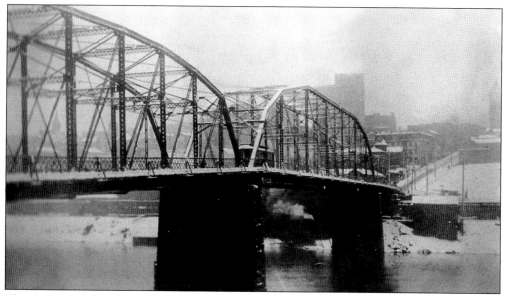

This postcard shows the iron bridge that was constructed to replace the suspension bridge. It was built on the same pylons that the suspension bridge sat upon. Near the center of this photograph, a streetcar is crossing the bridge. (MCHS.)

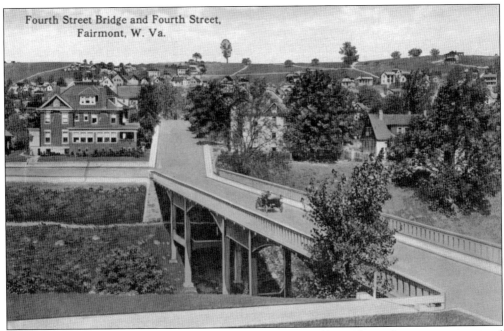

Fourth Street Bridge and Fourth Street,
Fairmont, W. Va.

This postcard shows a car driving across the Fourth Street bridge not long after it was constructed in 1920. Fourth Street crosses Coal Run Ravine and Benoni Avenue via the Fourth Street Bridge. The structure, which is slated to be replaced or relocated sometime in this decade, is part of the Fleming-Watson Historic District, which is listed in the National Register of Historic Places. (MCHS.)

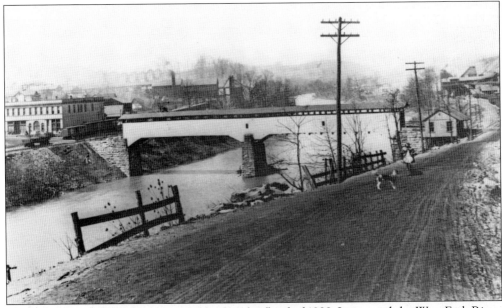

The Hunsaker Covered Bridge was built after the flood of 1888. It spanned the West Fork River, connecting Fairmont's south side with the Watson community. In the distance, past the upper left crest of the bridge, is Fairmont Coal Company's New England mine, which was purchased and modernized by James Otis Watson in 1894. (MCHS.)

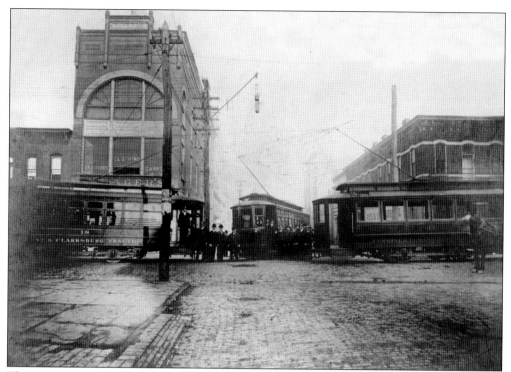

Three Fairmont and Clarksburg Traction Company streetcars and their conductors pose for a photograph at the intersection of Madison and Adams Streets. Behind the cars at left is Yeager's Department Store (later Golden Brothers), which was established at this location in 1879. This area was later known as the Golden Corner or the Golden Triangle. (MCHS.)

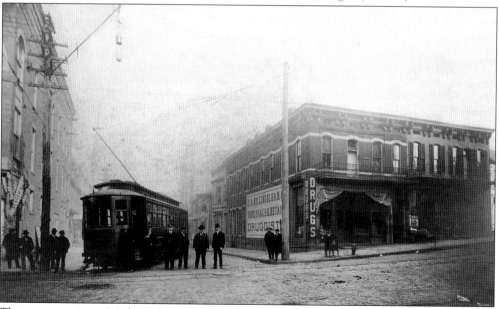

This streetcar sits on Madison Street between Yeager's Department Store and the F.A. Billingslea and Company drugstore. The streetcar conductor and others stand along Adams Street. Note the brick roads, the mailbox, and the fire hydrant. (MCHS.)

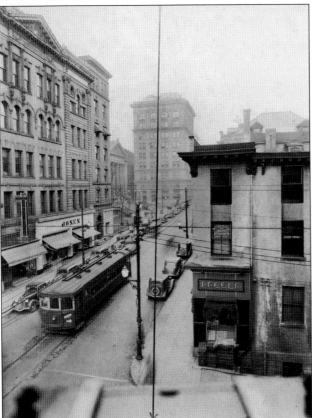

Model A Fords were produced and sold from 1927 to 1931 at a cost ranging from $500 to $1,200. Fortunately for Fairmonters, the popular cars were available at Carl Wilson and Ben Garrison's Central Automobile Corporation between Second and Third Streets on Fairmont Avenue. Above, Mike Potesta (left) and Bud VanGilder pose beside their 1929 Model A Fords. (Marjorie Potesta, in care of MCHS.)

This 1937 photograph was taken from the southwest corner of the Deveny Building on Adams Street as a streetcar passed. Across Monroe Street is the Kroger grocery store in what was formerly the T.W. Fleming Building, which once housed the Odd Fellows hall and the Great Atlantic & Pacific Tea Company (A&P). The law offices of Meredith and Beel are on the second floor. (MCHS.)

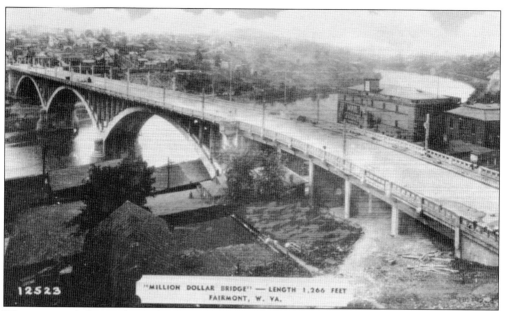

This postcard shows the Robert H. Mollohan-Jefferson Street Bridge—also known as the Monongahela River Bridge, the High Level Bridge, or the "Million Dollar Bridge"—crossing from west to east. The bridge's construction was completed in 1921. Huge crowds filled the bridge to celebration at its dedication on May 30, 1921. Nearly 80 years later, crowds again filled the structure to celebrate the bridge's refurbishment in 2000. (MCHS.)

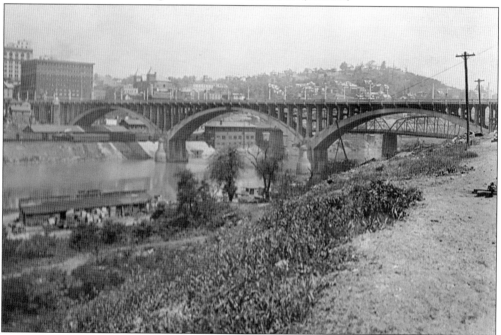

This photograph of the High Level Bridge was taken from the east side of the Monongahela River, in Palatine, looking northwest. The B&O Railroad depot is across the river and the ferry landing is in the foreground. The High Level Bridge was listed in the National Register of Historic Places in 1991, and it was repaired and reopened in 2000. (Kreed Holden.)

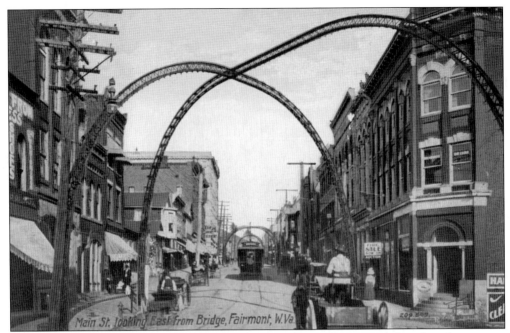

This early-1900s postcard looking east toward Adams Street shows several modes of transport, from horse-drawn carriages to the streetcar system and the formidable arches crisscrossing the landscape. In this photograph, both men and woman are wearing hats. (MCHS.)

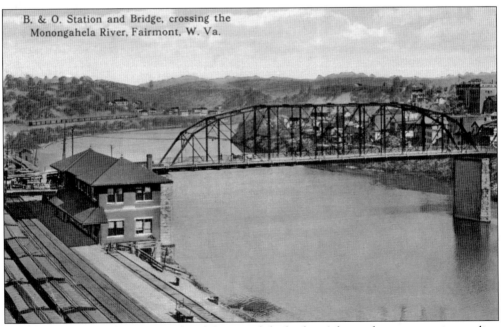

This postcard shows the B&O Railroad depot and the bridge. A horse-drawn wagon is traveling across the bridge from the east side, in Palatine, to the west side, in Middletown. (MCHS.)

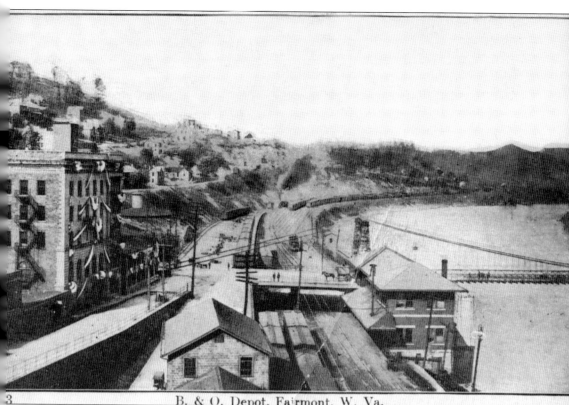

B. & O. Depot. Fairmont. W. Va.

In *Memories of Fairmont*, Allison Sweeney Fleming wrote that at one time, as many as 26 passenger trains per day traveled to Fairmont. Hotels competed for business by operating buses that would meet the trains and then bring customers over the very bumpy "Rocky Hill"—the lower part of Madison Street, which was comprised of rough road leading to the depot and suspension bridge. Because of Rocky Hill, in 1891, Mayor Thomas "Parks" Fleming, Allison's father, spearheaded the initiative to construct an easier approach to the depot by way of the New Dug Road; it was later called Parks Avenue (after Thomas Fleming) and was eventually officially renamed Cleveland Avenue. This postcard offers another view of the B&O Railroad depot and Skinner's Tavern on Parks Avenue. Skinner's, originally built by James Burns in 1847, appears to be outfitted for a patriotic celebration, as the facade of the building is draped with bunting, flags, and ribbons. (MCHS.)

The B&O Railroad depot served as a location for swearing in members of the military. This 1951 image shows Joseph Merendino (first row, far left) along with a group of others being sworn into the Air Force. Note that there are three women in the first row. Merendino's sister Patricia recalls that he was stationed in New Mexico and in New York, but had a longer tour in Anchorage, Alaska. She recalls writing to him often and sending him comic books in the mail. (Patricia Ann Merendino Greco.)

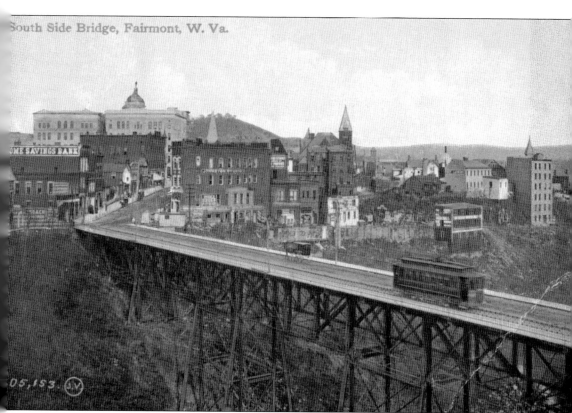

Another of Fairmont's bridges was the South Side Bridge, which was also known as the Col. George "Spanky" Roberts Memorial Bridge. George "Spanky" Roberts attended elementary and high school in Fairmont. He was among the first African-Americans selected for pilot training at the famed Tuskegee Army Airfield and commanded a fighter squadron while flying 78 combat missions over Europe in the Second World War. This bridge constructed over Coal Run joined Adams Street to Fairmont's South Side at Fairmont Avenue. In this image, a street car is crossing the bridge going south while a horse and buggy are going north toward Adams Street. A sign on the Carr building reads "Johnson Studio," and the steeple of the Methodist Protestant church on Monroe Street is also visible. Beneath this bridge was the Mid-City Parking lot, which no longer exists. An elevator was constructed in later years to transport people from the parking lot to street level so that they would not have to traverse the steep and dangerous steps. (MCHS.)

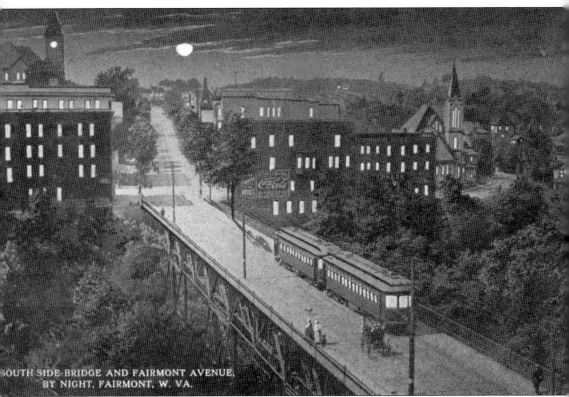

This nighttime view of the Col. George "Spanky" Roberts Memorial Bridge looks south toward Fairmont Avenue. Thanks to the Fairmont Development Corporation, the south side area was beginning to take shape. Fairmont Avenue continued southward to about Thirteenth Street, and homes and businesses began popping up along that stretch of road. The steeple of the Fairmont State Normal School is lit in the left background, and the steeple of the First Baptist Church of Fairmont, built in 1895, is at right, at the corner of First Street and Walnut Avenue. In 1902, a 10-room parsonage was built next door to the church. In 1907, a basement was added to the church, and in 1914, a large addition was constructed on the back. In 1919, a new bridge replaced the old steel one seen here. (MCHS.)

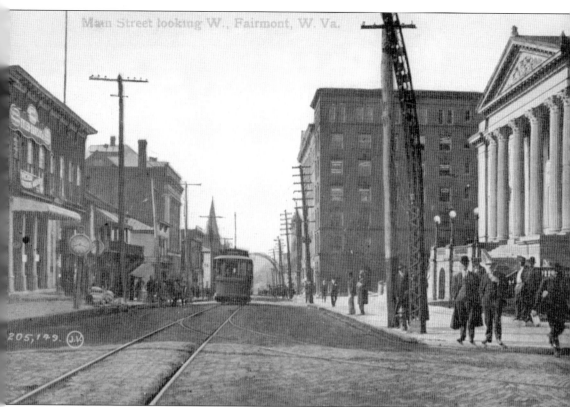

205,179. (J.V.)

This view of Adams Street looks southwest. This photograph was likely taken in 1908, as electric poles are visible and streetcars are present. The Marion County Courthouse is to the right, with the Fairmont Trust Company to its left. A Fairmont and Clarksburg Traction Company streetcar is visible, as are its rails, which are set into the street pavers. Just to the left of the pedestal clock, on the even-numbered side of Adams Street, is the Fleming/Cochran Building, which housed a jewelry store operated by Nathanial C. Cochran, a jewelry store operated by A.B. Scott, the Fanus Jewelry Company, a grocery store operated by Will "Moose" Fleming, the Dixie Theater, the *Fairmont West Virginian* newspaper, attorneys Harry G. Linn and W.S. Meredith, and a residence. (MCHS.)

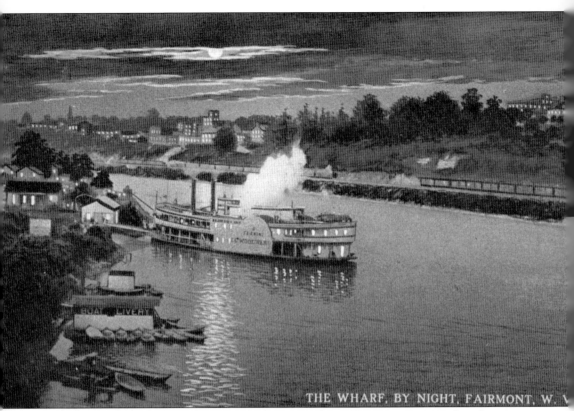

THE WHARF, BY NIGHT, FAIRMONT, W. V

In 1850, the *Globe* became the first steamboat to sail into Fairmont, proving that the river was navigable. It is possible that this vessel visited the area prior to 1850, but that was when it was first documented. In the mid-to-late 1800s, "packet ships" or steamboats often traversed the rivers, transporting salt, whiskey, groceries, merchandise, and tobacco. Other river vessels that visited Fairmont include the *West Virginian* in 1873 and the *Elector*, a side-wheel steamer, in 1876. According to Sylvester Myers's *History of West Virginia*, steamboats and other smaller boats were dependent on the water level of the river, which varied. During long periods of low water levels, boats could only travel to Fairmont a few times in a season. In this postcard, the steamboat *I.C. Woodward* docks at the city wharf, which appears to have been in Palatine. (MCHS.)

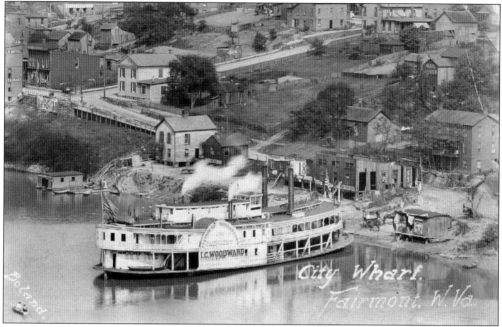

This is another postcard of the *I.C. Woodward* docked at the city wharf. The boat livery is to the left of the steamboat, and just above the livery, Water Street intersects with Ferry Street. Looking closely, a horse and wagon are in front of the steamer, and there are two people in a johnboat in the lower left corner of the image. (MCHS.)

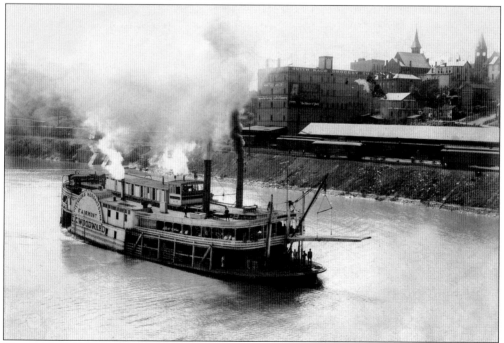

This pre-1852 photograph of the *I.C. Woodward* steamboat looks from east to west. Note the advertisement for "Mail Pouch" tobacco on the side of the Smith-Race Grocery Company building on the west side of the river. (MCHS.)

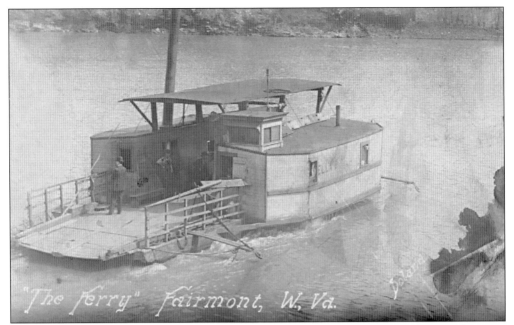

This ferry was used to transport goods, people, horses, and buggies across the river between Palatine and Fairmont. It docked at the city wharf on the east side and at the mouth of Coal Run on the west side and remained in use until the suspension bridge was erected in 1852. (MCHS.)

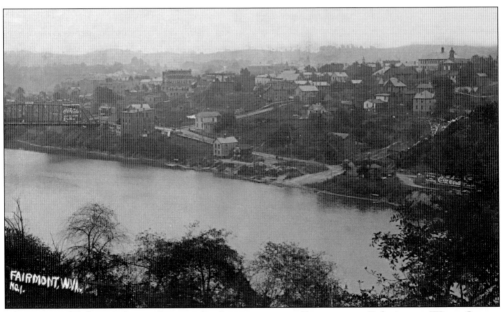

This view of Palatine shows the iron bridge connecting Fairmont to Palatine at Water Street. The City Hospital is visible just above the Coca-Cola mural on the left side of the photograph. The city wharf is to the right. The Central (First Ward) School is in the upper right part of the photograph. (MCHS.)

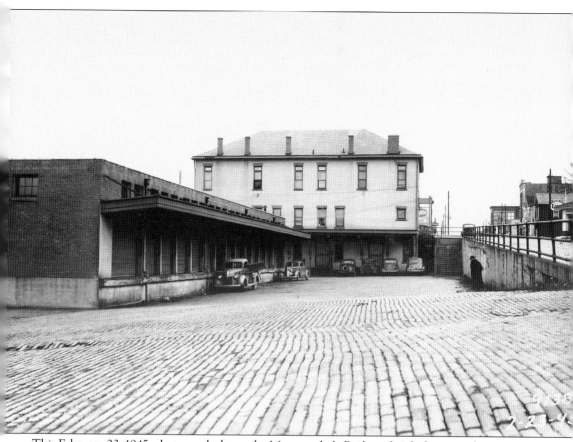

This February 23, 1945, photograph shows the Monongahela Railway freight house and passenger depot, which was on the east side of Fairmont, in Palatine, along Merchant Street. It housed 14 bays for loading and off-loading freight. It was later operated as a Railway Express Agency (REA), which was run by the federal government and transported small packages and parcels. Just across Merchant Street to the right is an Esso gas station (with its sign barely visible). Note the ladder truck parked in front of the dock. This depot was eventually razed, and today, an AutoZone auto parts store is in this location. (MCHS.)

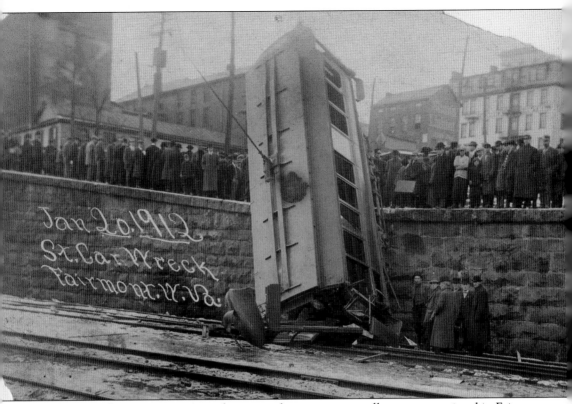

The interurban transport system, known as the streetcar or trolley, was operational in Fairmont from 1900 to 1948. It started out as the Fairmont and Clarksburg Traction Company and went through several name changes, including stints as the Monongahela Valley Traction Company and the Monongahela West Penn Public Service Company. It was eventually owned and operated by the Monongahela Power Company. It served the populations of Fairmont, Clarksburg, Weston, Fairview, Mannington, and the surrounding communities. One could travel on the streetcar from Fairmont to Weston in about 36 minutes. In this photograph, the streetcar appears to have veered off its track and jumped over the stone wall at Walker Siding. The accident happened on January 20, 1912, just below Skinner's Tavern. The Yost Building is visible at right just above the crowd; that building was the scene of a deadly streetcar accident in 1927. (MCHS.)

Seven

ARTS AND ENTERTAINMENT

From minstrels to vaudeville to the big screen, Fairmont had it all. The city contained numerous theaters where actors such as Fuzzy Knight could showcase their talents, big bands like Jimmy Morgan's could entertain, and variety shows could dazzle audiences. Longtime residents may recall the old Hippodrome Theater on Adams Street before it was sold and renamed the Blue Ridge Theater, or the Opera House on Monroe Street, or the Virginia Theater on Adams Street. The theater was not the only place for entertainment—Fairmont celebrated holidays with parades; hosted fairs, circuses, and carnivals; and supported area sports teams as well as encouraging participation in various other recreational activities.

Additionally, the Fairmont State Normal School greatly contributed to the arts—not only in Fairmont but internationally. In 1925, Fairmont State College faculty director Paul F. Opp, along with students at the college, created the national theater honor society called Alpha Psi Omega for students at four-year colleges; in 1929, they added Delta Psi Omega for students at junior (two-year) colleges. Also in 1929, Opp and Fairmont community members Harry Leeper and Ernest Bavely (Opp's secretary) created the National Thespians (now known as the International Thespian Society), an honorary society for high school students. The first Thespian Troupe was formed at Natrona High School in Casper, Wyoming. All three societies now include millions of members across the world.

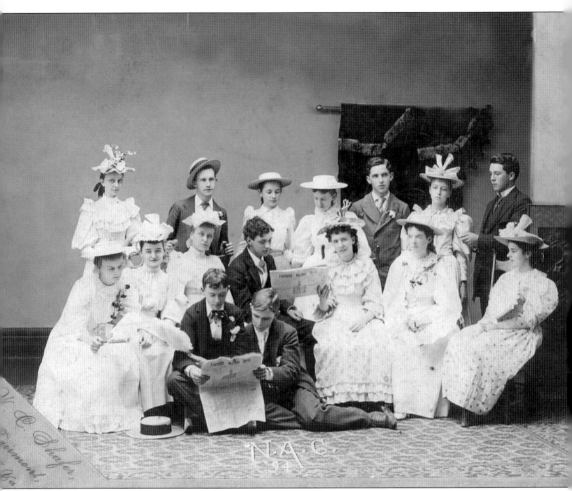

In this 1894 photograph, theater students appear to be reading the Fairmont Normal School's newspaper, the *Fairmont Normal Daily*. The young women wear bonnets and floor-length dresses, while the young men wear three-piece suits and ties. Fairmont Normal School (later Fairmont State University) maintained a robust theater troupe—the Masquers, Fairmont State University's student theatrical production organization since 1923, continues to present a season of plays, varied in style and period and usually performed in the Wallham Hall Theatre, during the fall and spring semesters. The plays are directed, designed, and supervised by the communication and theater faculty and/or guest artists. Alpha Psi Omega was organized at Fairmont State University in 1925 by Fairmont State College faculty director Dr. Paul Opp. With more than 600 chapters, Alpha Psi Omega is now the largest national honor society in America. (MCHS.)

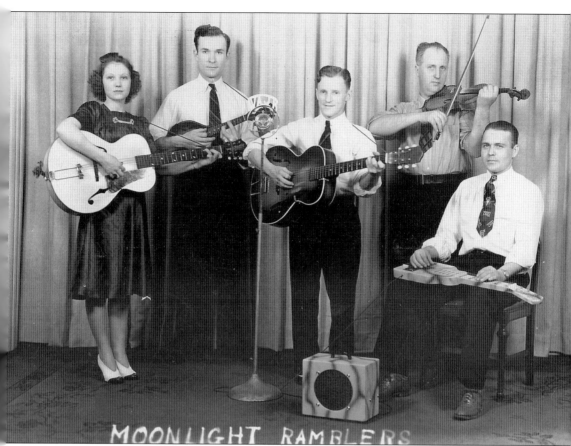

This 1941 photograph shows the musical group the Moonlight Ramblers, whose members included, from left to right, Thelma and Luther Carter, Shorty Hess, John Markley, and Paul Hostutler. Musical groups were often showcased on the WMMN radio station or at local social clubs such as the Elks or Moose. In the early days, Fairmonters could find their entertainment at the Hippodrome, the Grand Opera House, or at any number of theaters, saloons, skating rinks, or bowling alleys. Stock companies and various attractions also frequently came through town, as did several minstrel groups. According to E.C. Jones, as told to Glenn Lough, there was a nickelodeon on Madison Street near the Watson Hotel with loud speakers outside, which charged a 5¢ admission. (MCHS.)

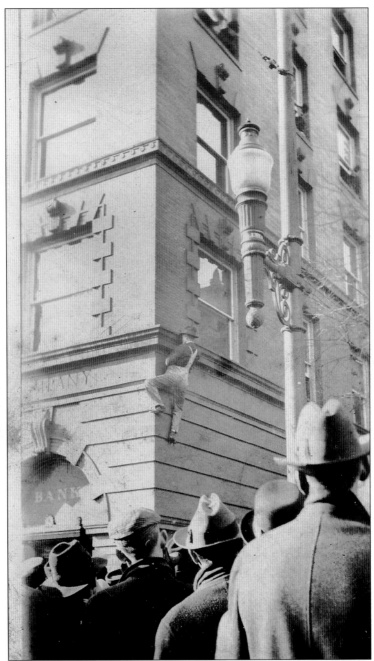

Onlookers watch in the cold as the man they called the "human fly" scales the Fairmont Trust Company building at 209 Adams Street on February 12, 1917. Wearing only clothing, gym shoes, and gloves, he climbed from window to window until he reached the top of the seven-story building next to the Marion County Historical Society & Museum. Note that someone is hanging out of a fourth-floor window, presumably encouraging the human fly along. A number of men climbed buildings under the "human fly" moniker at the time (before 1918), including Harry Gardiner and George Gibson Polley. Both traveled the country doing such performances, although the gentleman pictured here has not been confirmed to be either of those men. (MCHS.)

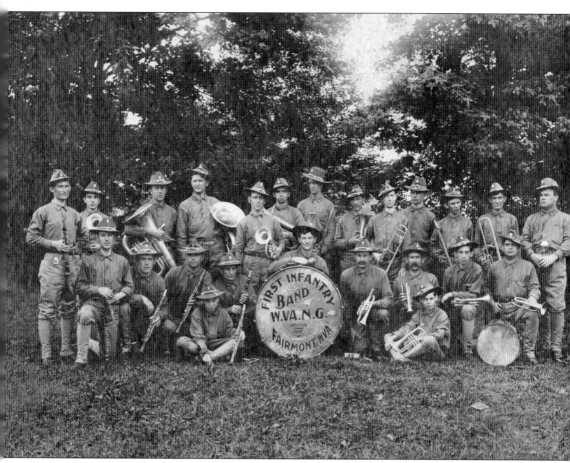

During the Civil War, leaders of both the Union and the Confederacy relied on military musicians to entertain troops, position troops in battle, and spur them on to victory. The infantry and band of the 1st Regiment, West Virginia National Guard, were based in Fairmont. The 1st West Virginia Infantry mobilized on March 28, 1917, for service in World War I and became part of the national fighting forces on August 5, 1917. The 1st West Virginia Infantry Band, pictured here, included several very young men. Common instruments in bands of this type included the clarinet, trumpet, piccolo, bugle, tuba, trombone, and snare drum. (MCHS.)

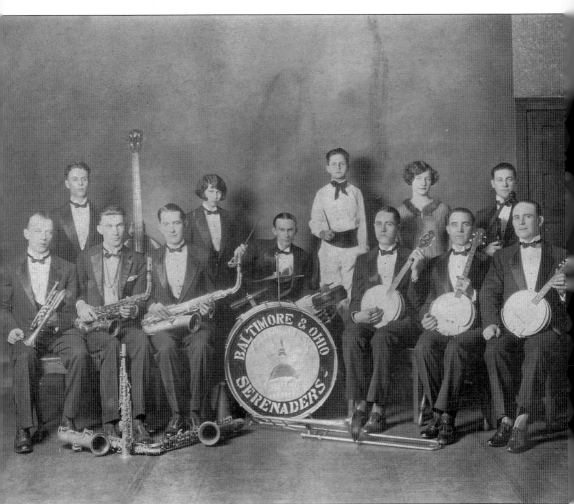

This is an early photograph of the Baltimore & Ohio Serenaders. The drummer was Jimmy Morgan, and to the left of Morgan is Mary McAteer, whom Morgan later married. Morgan was a well-known bandleader of his day, and his band often played at any and all venues, including school performances. The rest of the band included, from left to right, (first row) Mr. Russell, Denzil Amos (saxophone/clarinet), Harry Cordie (saxophone), Benjiman Graham (banjo), Freeland Burs (banjo), and Jack Mowery (banjo); (second row) Fred Wilson (bass), McAteer (piano), Morgan (drums), Jack Mowery's unidentified son, an unidentified makeup girl, and Eddie Schneider (violin). (MCHS.)

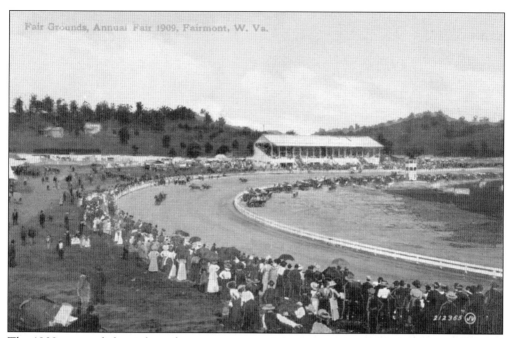

Fair Grounds, Annual Fair 1909, Fairmont, W. Va.

The 1909 postcard above shows horse racing at the annual Marion County Fair. It appears to have been quite an event, with spectators wearing their Sunday best. Note the automobiles parked in the center of the track. In his 1950 book, *Memories of Fairmont*, Allison Sweeney Fleming writes, "[The fair] was at the far end of Maple Avenue and had a circular race track, grandstand, and baseball diamond." (MCHS.)

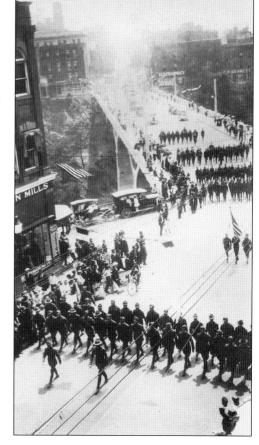

Onlookers enjoy a parade through downtown Fairmont as it proceeds from the South Side Bridge onto Adams Street. The Carr Building, on the right at 100 Adams Street, was home to the Union Woolen Mills. Weber's Florist was later constructed in the location where the cars are parked at center-left. (MCHS.)

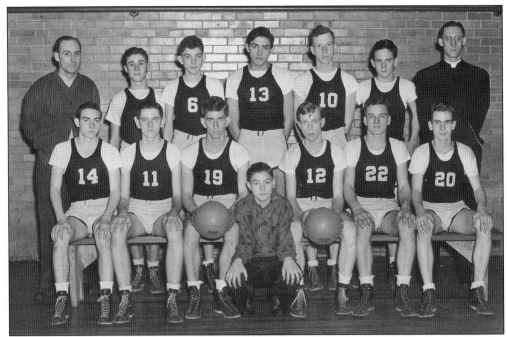

Sports played an important part in socializing and education. Father Allison (back row, far right) is pictured here in the 1940s with the St. Peter the Fisherman Roman Catholic School's basketball team. (Patricia Ann Merendino Greco.)

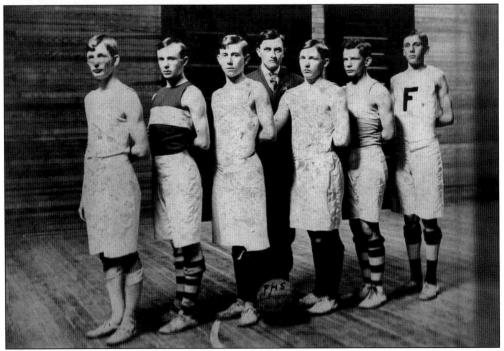

This is a photograph of the Fairmont High School basketball team. This team would have attended and played for the school at the Fifth Street location sometime before it became a junior high school in 1929. (MCHS.)

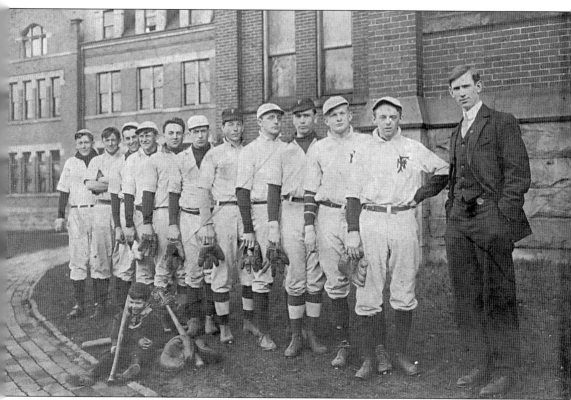

The Fairmont Normal School's 11-member baseball team stands in front of the school on Second Street with their team manager, Lawrence Conaway (far right). The caption on the back of the photograph notes that many Fairmont Normal School students traveled by train to attend school. This photograph was taken sometime after 1908 and before 1916. As a student, Conaway was captain of the school's baseball team in 1908.

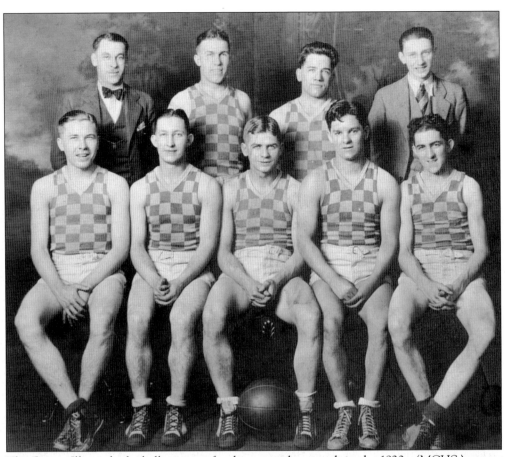

The Owens-Illinois basketball team sat for this team photograph in the 1920s. (MCHS.)

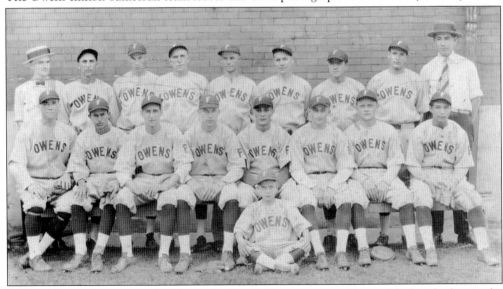

Owens-Illinois also sponsored a 15-member baseball team, pictured here with their batboy in the 1930s or 1940s. (MCHS.)

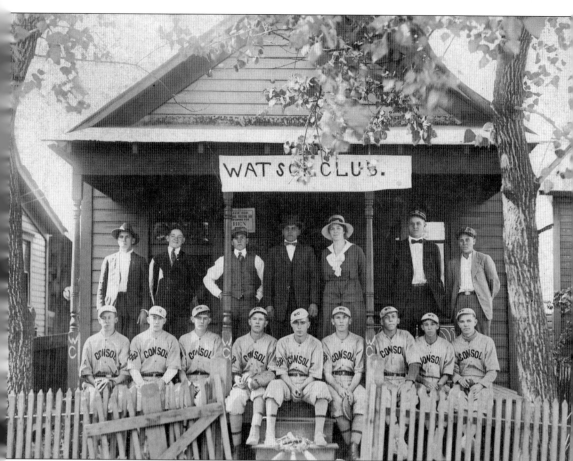

In March 1903, Arch and Ralph Fleming spearheaded the formation of the Fairmont Baseball Association (FBA), which created the city's first semiprofessional baseball team, the Coalers. By 1906, the Flemings made a portion of their farm on the south side available for development by the FBA. Under the direction of vice president and operator Thomas S. Haymond, the Fairmont and Clarksburg Traction Company built a state-of-the-art baseball field along its streetcar line near Twelfth Street, known first as South Side Park, then Traction Park, and now as East-West Stadium. Industrial leagues lasted until 1917 in the Fairmont area. About this time, Consolidated Coal Company (CCC) established an employment relations department to manage their baseball program. With the advent of the "coal wars," operators financed baseball teams to help unify their workforces. They looked for good players, usually rewarding them with easier jobs, shorter working hours, and time off. The team shown here around 1920 is the Watson Club, which was sponsored by CCC. (MCHS.)

The Melody Manor on Locust Avenue in Fairmont was a favorite nightspot for bands and generations of Fairmont dancers. Among the group posing for this photograph are Minnie Colantino Bitonti (first row, far left) and her husband, Frank (second row, second from left), who were said to have been two of the area's best dancers. (Bitonti family.)

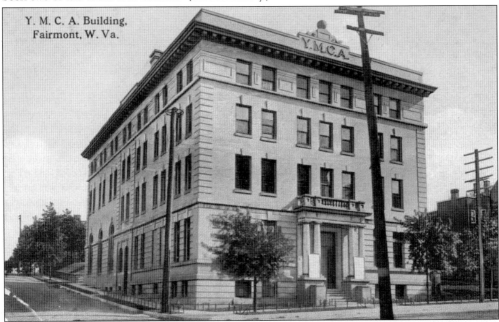

Recreation could also be had at the YMCA, which was located on the second floor of the J.W. Lott Building on the corner of Madison and Adams Street in 1894. This photograph of the building on Fairmont Avenue is from around 1920, when there was an active membership. Membership later declined, and the building was sold to the local Moose Club in 1940. (MCHS.)

Reuben "Rubie" Fink was not only a well-known merchant, but also a stage and radio performer. In WMMN Radio's pioneer days, Fink and Lorain Gainer formed a comedy team, Two Black Aces, that became a regular feature. They were on the air every Friday night and soon built up a steady following. They wrote their own material, and the radio program was narrated by Pat Moran. A September 12, 1954, article in the *Times West Virginian* called them two of the most unique blackface comedians in the country. Fink is pictured here, most likely at the Moose Club in the late 1940s or early 1950s. (Chuck Fink.)

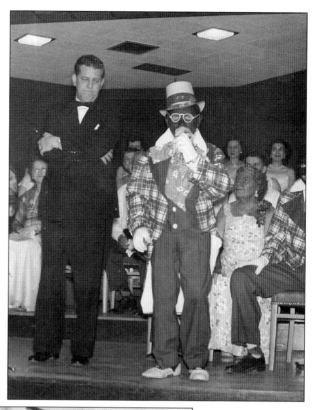

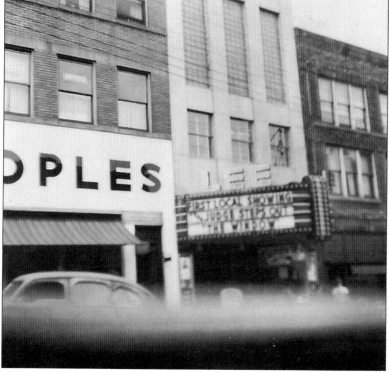

The Lee Theater is pictured here in the 1950s. Wayne Kirby and his wife, Joyce, both worked at the Lee Theater and remember it fondly. Wayne was a projectionist and usher, and Joyce was a ticket taker and worked in the candy store. These buildings were eventually razed to create space for a parking lot for Wesbanco Bank. (Chuck Fink.)

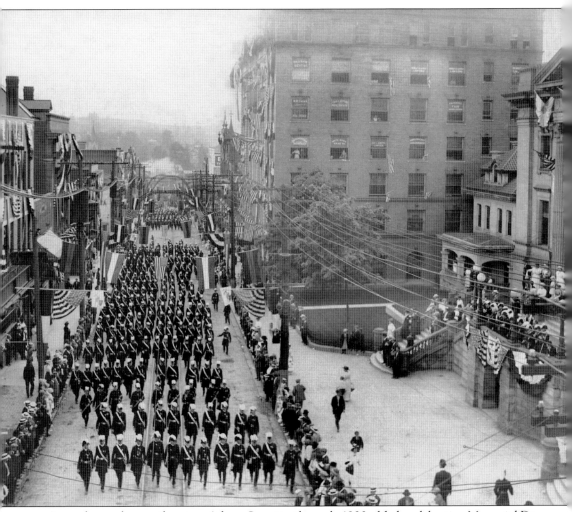

A parade marches northeast up Adams Street in the early 1900s, likely celebrating Memorial Day or the Fourth of July. Next to the courthouse (shown at right) is the county sheriff's residence, which is now home to the Marion County Historical Society. (MCHS.)

BIBLIOGRAPHY

Akin, William E. *West Virginia Baseball: A History, 1865–2000.* Jefferson, NC: McFarland and Company, Inc., 2006.

Cole, Merle T. *A Comprehensive History of the West Virginia State Police, 1919–1979.* Self-published, 1998.

Dilger, Dr. Robert Jay. *Early History of Marion County.* Morgantown, WV: self-published.

Dunnington, George A. *History and Progress of the County of Marion.* Fairmont, WV: self-published, 1880.

Fleming, Allison Sweeney. *Memories of Fairmont, West Virginia: My Own Home Town.* Fairmont, WV: Fairmont Rotary Club, 1950.

Haymond, Henry. *The Haymond Family: Brief Sketches, Official Papers, and Letters.* Morgantown, WV: Acme Publishing Company, 1903.

J.O. Watson class of Fairmont High School and Dora Lee Newman. *Marion County in the Making.* Fairmont, WV: Meyer and Thalheimer Publishing, 1917.

Lang, Theodore F. *Loyal West Virginia from 1861 to 1865.* Baltimore: Deutsch Publishing Company, 1895.

Lough, Glenn D. *Now and Long Ago: A History of the Marion County Area.* Morgantown, WV: Morgantown Printing and Binding Company, 1969.

McMillan, Debra Ball. *An Ornament to the City: Historic Architecture in Downtown Fairmont, West Virginia.* Terra Alta, WV: Headline Books, Inc., 1996.

Myers, Sylvester. *Myers' History of West Virginia.* Wheeling, WV: The Wheeling News and Lithograph Company, 1915.

Neely, John Champ. *The Big Yellow Cars: A Nostalgic Look at a Remarkable Interurban Streetcar System.* Fairmont, WV: Fairmont Printing Company, 1987.

Six, Dean. *West Virginia Glass Towns.* Charleston, WV: West Virginia Book Co., 2012.

www.wvencyclopedia.org

DISCOVER THOUSANDS OF LOCAL HISTORY BOOKS
FEATURING MILLIONS OF VINTAGE IMAGES

Arcadia Publishing, the leading local history publisher in the United States, is committed to making history accessible and meaningful through publishing books that celebrate and preserve the heritage of America's people and places.

Find more books like this at
www.arcadiapublishing.com

Search for your hometown history, your old stomping grounds, and even your favorite sports team.

Consistent with our mission to preserve history on a local level, this book was printed in South Carolina on American-made paper and manufactured entirely in the United States. Products carrying the accredited Forest Stewardship Council (FSC) label are printed on 100 percent FSC-certified paper.

MADE IN THE USA